IMAGES
of America

CEDAR LAKE

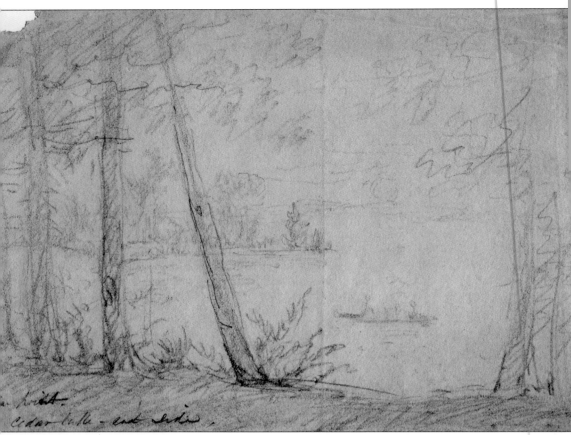

Cedar lake — east side

The Cedar Lake area was once part of the province of Quebec. It became the Indiana Territory in 1800 and was admitted to the Union as the State of Indiana in 1816. The name Indiana means "land of the Indians," and the Potawatomi Indians lived in the wilderness surrounding Cedar Lake. A village on the northeast shore of the lake called Mes-kwah-ock-bis, meaning Red Cedar Lake, is the origin of the name "Cedar Lake." As part of the Treaty of 1832, the Potawatomi sold their land to the federal government. Artist George Winter was concerned about the changes forced upon the Indians and came to northwest Indiana to record their lives. Few Indians were left when he travelled here in 1844. The notation in the bottom corner of this pencil drawing reads, "Cedar Point Cedar Lake—east side." A scan of Winter's original sketch was made at the Tippecanoe County Historical Society in Lafayette, Indiana. (Courtesy of the Tippecanoe County Historical Society.)

ON THE COVER: Cedar Lake has been a resort community for many years. This couple is unidentified, but they are likely Chicago residents visiting a summer cottage in Cedar Lake. The automobile license plate is stamped 1926. Gus Wahlberg, who opened his camera shop on the eastern shore in 1926, captured the image. We are fortunate to have had this photographer in Cedar Lake, since many of the images in this book are Wahlberg's photographs. (Courtesy of the Lake of the Red Cedars Museum.)

IMAGES
of America

CEDAR LAKE

Carol Ann Oostman and the
Lake of the Red Cedars Museum

ARCADIA
PUBLISHING

Published by Arcadia Publishing
Charleston, South Carolina

Printed in the United States of America

Library of Congress Control Number: 2011933335

For all general information, please contact Arcadia Publishing:
Telephone 843-853-2070
Fax 843-853-0044
E-mail sales@arcadiapublishing.com
For customer service and orders:
Toll-Free 1-888-313-2665

Visit us on the Internet at www.arcadiapublishing.com

This book is dedicated to my family—Joe, Jeff, Kim, Jake, Travis, and Jack, but mostly my husband, Leroy, for his help and patience.

CONTENTS

ACKNOWLEDGMENTS

My biggest thanks go to Anne Zimmerman, director of Lake of the Red Cedars Museum. Without Anne, this book would never have come together. Many thanks go to the following for their time and photographs: Gary Alexander, Michelle Bakker, Harry Beamer, Nancy Bilow, Mary Boomsma, Richard Brewer Sr., Larry Coffin, Merritt Coffin, Sandra Dalkalic, Linda Dekker, Cyndee DeVries, Bob Eberle, Keith Eenigenburg, Donald Gard, Bob E. Gross, Mary Hays, Terry Heldt, Mylene Coffin Hollar, Dave Howkinson, Chuck James Sr., Diane Jostes, Albert Keown, Thomas Kepshire, Edward King, Ron Kors, Chuck Kouder, Bob Kralek, Jan Welk Kretz, Jim Kretz, Marion LoVerde, Donna Mager, Lou Ann Miller, Dr. Jon Misch, Dr. William and Mary Lou Misch, Frederick Oparka, John Pagorek, Doreen Pittman, Donna Radford, Darlene Rigg, Francis Salvador, Bill Schrik, Brian Sok, Diane Sprehe, Judy Stoll, Emily Sumara, Jim Thorn, Pam Thorn, Jane Unger, Susan Wahlberg, Jim Watt, Don Woodburn, Bernard Wornhoff, Gregory Lee Wornhoff, Jimmy Xerogiannis, Linda Yancey-Sharp, Rich Yancey, and Paul Zimmerman.

Photographs appear courtesy of Kathy Beilfuss (KB), Scott Bocock (SB), Al Bunge (AB), Bob Carnahan (BC), Cedar Lake Fire Department (CLFD), Mike Danneman (MD), Betty Eaton (BE), Ray Ferry (RF), Steve Govert (SG), Ted Gross (TG), Ryan Henderlong (RH), Richard (Dick) Henn (DH), Fred Holloway (FH), Chuck Howkinson (CH), John F. Humiston photographs, Richard Humiston (JFH), Gregory Jancosek (GJ), Don King (DK), Mary Alice Koehler (MAK), Kathleen Krumm (KK), Brian Kubal (BK), Martie Kubal (MK), Lake of the Red Cedars Museum (LRCM), Tom McAdams (TMA), Steve McShane at Calumet Regional Archives-Indiana University Northwest (IUN), Heidi Mees-Duncan (HMD), Dick Norris (DN), Carol Oostman (CO), Craig Parker (CP), police chief Roger Patz (PCRP), George Poponas (GP), Sandi Reitsma (SR), Gerri Rudzinski (GR), Mitzi Schowalter (MS), John Schutz (JS), Wayne Stoll (WS), Alayna and Dennis Summers (ADS), Todd Taylor (TT), Tippecanoe County Historical Society (TCHS), Linda VanHorn (LVH), and Anne Zimmerman (AZ).

Thank you to Midwest publisher John Pearson and editors Anna Wilson and Jeff Ruetsche for guiding me through the book preparation process, and mostly thank you to my husband, Leroy.

INTRODUCTION

Hervey and Jane Ball came to this area in 1837. Jane started the first log school, and their son Timothy H. Ball was a circuit preacher who recorded early history. As he rode on horseback between pioneer homes, he passed the time by writing details of people and nature. Much of that writing is not common knowledge, but there is one facet of the Ball legacy that everyone knows: Grandmother Horton, Jane's mother, was feeble and the children planted wild columbine and roses outside her window. However, the children could not find the yellow flowers Grandmother Horton remembered from Connecticut. The family sent for seeds, and the children planted them around the home, introducing the unidentified flower to the area; Grandmother Horton soon enjoyed the familiar yellow of dandelions.

The town of Paisley bordered the lake's southwest corner in the late 1800s. Mark Webber built the Webber Hotel, also called Paisley House, as the Chicago, Indianapolis & Louisville Railroad—known as the Monon—was laying tracks into town in 1880. A train depot was built in 1882 on the present-day site of Pine Crest Marina. Depot agent Harrison Ford also ran a general store that housed the post and telegraph offices. Shoemaker Eugene Hare cut soles from Monon train car air hoses at a time when residents owned one pair of shoes. The Rosenbaur Saloon and Cecil Mitch's Pier served customers, while the Howkinson family farmed the swamp and beyond to the west. Children attended the Schutz School or Paisley School. In 1898, the Paisley depot closed, and the little town faded away by 1930.

Hanover Center included acreage west of the lake between the New York Central Railroad and Route 41. The village was called Hanover Center because many of its inhabitants emigrated here from Hanover Province, Germany. At first, a Hanover sign was hung at the small depot along the railroad tracks. But since there was already a Hanover down the line, the depot was renamed Cook, after a railroad official. Herman Beckman raised hogs and hauled wagons of fat hogs up the dirt road called Route 41 into Chicago. He sold the hogs, used the money to buy lumber, and built Hanover Center's first store in 1855. In 1867, Frank Massoth bought Beckman's store, which was located on the southeast corner of Route 41 and Adeway. Route 41, also called Wicker Avenue, was upgraded from dirt to concrete in the 1920s and became the main automobile access to the lake with a turn onto Adeway, now called 133rd Avenue. In 1880, the village adopted the depot name and became known as Cook. While other small towns faded away, the hardworking Germans of Cook maintained their commercial district, which became an asset to Cedar Lake after incorporation.

Armour Town bordered the lake's northwest corner and was home to historians Timothy H. Ball and Bea Horner Castrogiovani. The town is memorialized with a rock along 133rd Avenue, showing that the town named after the Armour brothers was established from 1870 to 1970. Roads were lined with about 18 residences and the Mellwood, Armour, and Hein Hotels. Children were warned to stay away from the fence separating the town from the rough characters in Monon Park. Peter J. Howkinson and Knickerbocker Ice owned the first ice barns here. Philip and Jonathan

Armour inspected those operations, then opened their own barns on the town's shoreline to supply the Armour and Swift meatpacking houses in Chicago—these are the same Armours of 1970s hot dog fame. John G. Shedd also had ice-farming interests. There is a good chance that part of the money Shedd donated for Chicago's Shedd Aquarium came from Cedar Lake ice. Local men worked the ice, but more were needed for this cold, hard work, so additional men were recruited from Chicago's Skid Row. They stayed in the Armour Hotel, were paid when the season ended, and were sent back to Chicago on the train. Local citizens did not mingle with the hoboes. Armour was about a half-mile long and a half-mile wide. When mechanical refrigeration replaced wooden iceboxes, the ice farming industry faded away, along with the town.

William Scholl grew up near LaPorte, Indiana. His grandfather Peter Scholl was a shoemaker living in Armour. When William came to visit, he received his first lessons about shoes and feet from Grandpa Scholl. Around 1900, William opened a shoe repair shop in Armour. He only stayed a short time before moving to Chicago to study medicine and going on to design his famous footwear.

Dr. Calvin Lilley ran a general store on the eastern shore from 1837 to 1839. A daybook entry from July 1839 shows that he sold one pound of saleratus (baking soda) for 19¢, six yards of calico for 24¢ per yard, one pound of raisins for 25¢, and one gallon of whiskey for 56¢. In 1840, Judge Benjamin McCarty bought the store and nine acres. McCarty laid out and named streets and called the village West Point. A permanent county seat had not been established, and Judge McCarty wanted West Point to receive that honor. West Point, Liverpool (now Lake Station), and Crown Point were in the running. However, Crown Point was chosen. McCarty was displeased, moved south, and little West Point faded away.

About a mile south of West Point, William Taylor erected a steam mill at the Cedar Creek outlet in 1854. Taylor tried to establish a town with 212 lots around the mill and called it Fairport. In 1858, Warne Gray bought the property and renamed the area Graytown. Neither town flourished, and both were abandoned. Around 1870, John and Christopher Binyon bought the property and built the Binyon Hotel just south of the Cedar Creek outlet. In 1882, Christopher Binyon sold some of the northern land to Frank W. Stanley. Stanley and his black caretaker Addison Holmes were fine craftsmen who built a house, a caretaker's dwelling, and a bowling alley near the shore. The complex was called Stanley's Place. The next owner of the nearly 30 acres was Enoch Peterson. The area has been called Hickory Subdivision and also Henderlong Subdivision. South of the Binyon Hotel sat two Olson Hotels and the Norwegian Boat Club, where the Olson brothers built small sailboats. This area is now Wilson subdivision.

Cedar Lake's ice age passed, along with the hotel era. The towns of Paisley, Armour, West Point, Graytown, and Fairport faded away. Hanover Center became Cook, and Cook remained to eventually become part of Cedar Lake. The incorporation of Cedar Lake stretched over several years; it was an uphill battle and not everyone was pleased when the final incorporation of Cedar Lake became reality. The long, drawn-out process was the most costly incorporation of any town in Indiana—and perhaps the nation—in 1969. But the areas surrounding the lake did come together as Cedar Lake, sewers were installed, and improvements began. Plans come and go—some are successful and others fail, but the end result is what we are today.

The following pages offer a photographic tour around Cedar Lake from 1844 to the present. It is not possible to include every person, place, and photograph here. But the photographs are real, the information is honest, and hopefully they reveal interesting bits of Cedar Lake's past.

One

WEST SIDE

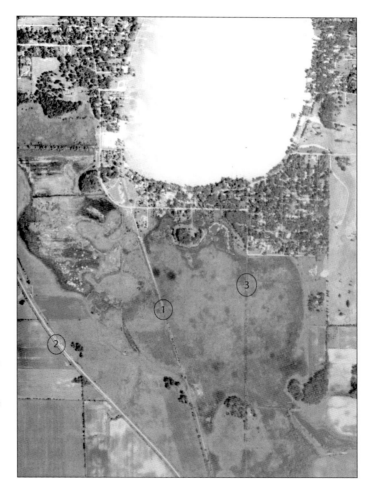

In 1882, the Monon Railroad ran tracks from Creston, over the swamp, and along the western shoreline. This 1965 aerial shot shows traces of the old tracks in the center (1). By 1948, the tracks were moved west, as shown on the left (2). In 1875, there was no direct road between the lake and Creston, so residents built a plank road over the swamp, shown at right (3), which was used until it became unsafe. (MAK.)

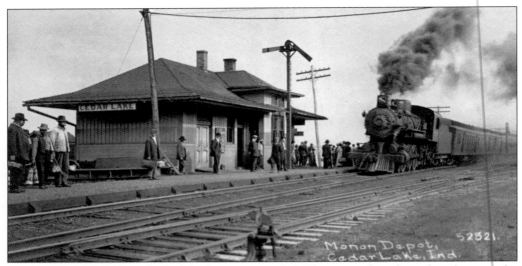

Steam engines ran alongside the lake from 1882 to 1948. They spewed smoke and cinders over the countryside and were loud and shook nearby buildings, but they provided work for many. The trains also brought barrels of coffee beans, bundles of overalls, tin food containers, and much more. Some of these businessmen are likely headed to work in Chicago in this 1912 photograph. (LRCM.)

Railroad men kept the trains running and were heroes in 1920. Pictured here are, from left to right, Harry Albertson, Sonny Rosenbaur, Jane Biesecker, and Peter Saberniak. Jane was there because her father, Monte Biesecker, was the stationmaster. Monte was in charge of raising the semaphore when it was safe for a train to proceed. Once, he was ordered to raise the flag before it was safe. He refused and was later fired. (LRCM.)

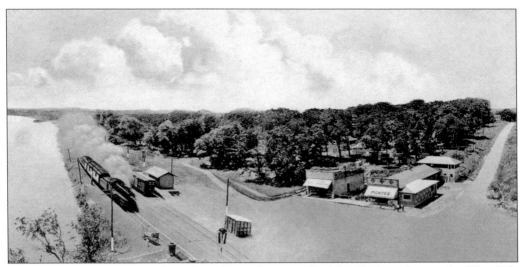

This 1898 photograph shows how close the tracks ran to the lake. To the right was the West Side Shopping Center. When Monte Biesecker was fired, he bought an empty lot, built a house, and then sold both the lot and home. With Henry Henn and Jim Watt, he built more houses in the nearby Lakeshore Subdivision. Then, he managed the store shown at right, selling souvenirs, postcards, drinks, and groceries. (SR.)

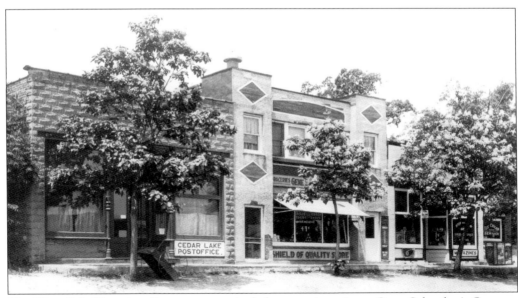

The West Side Shopping Center grew to include, at various times, Gene Schreiber's Grocery, the Cedar Lake Post Office, a library, Stillson's Grocery, and others. Linda VanHorn remembers walking to Stillson's to use the only telephone in the neighborhood. Sylvester Schreiber drove the school bus and picked up students at the shopping center. The Schreiber farm was sold and is now home to the new Hanover Central Middle School at 10631 West 141st Avenue. (ADS.)

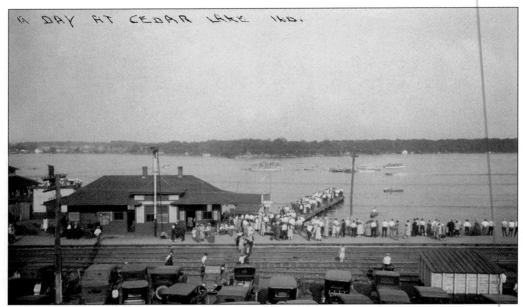

In 1898, the Paisley and Armour depots closed, and this third depot, called Cedar Lake, was built north of Paisley. The depot was so close to the water that some of the lakefront was filled in before the foundation was laid. This photograph is from 1923, when large numbers of tourists disembarked from the train, then boarded a boat for a ride to their hotel across the lake. (LRCM.)

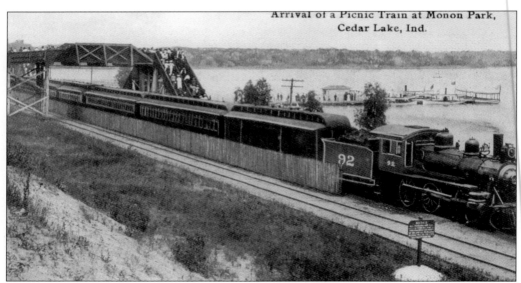

In 1900, four trains left Chicago's Polk Street Station each day for a two-hour trip to Cedar Lake. Thousands of tourists left the hot city and flocked to the clear waters and picnic groves. They exited the train on the lake side of the tracks, climbed the stairs, and crossed over to Monon Park. The park soon became crowded, and Monon purchased another park area to the north. (LRCM.)

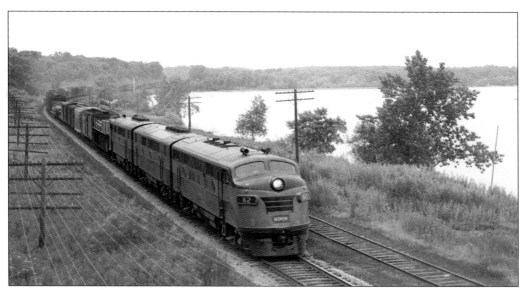

Engine No. 62 pulled a long line of freight cars south around the northwest shoreline in the summer of 1948. Diesel locomotives were replacing steam engines, and the freight itself changed. Trains had hauled ice that was farmed from the lake, but that era passed. Farmers no longer brought their milk cans to the station platform each day. Change was coming. (JFH.)

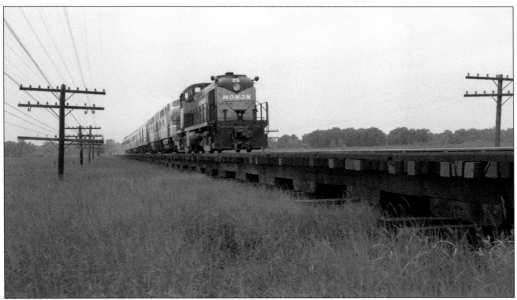

In 1882, laying tracks over the swamp presented a challenge. Piles were driven 90 feet down but never hit solid ground. Fill was dumped and disappeared. This 963-foot wooden bridge was called the Paisley Trestle. It was an engineering feat, yet this floating structure was not stable and required speeds of 20 miles per hour over the span. Locals tell of a locomotive falling into the bog and disappearing—fact or fiction? (JFH.)

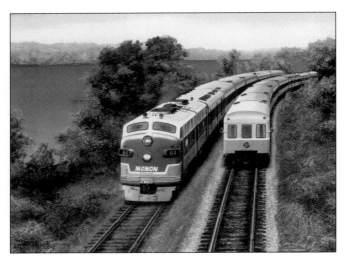

In the summer of 1948, train No, 11, the "Tippecanoe," passed along Cedar Lake, but the future looked grim. The Paisley Trestle was a liability, and children were scampering over the tracks to reach the lake. In November 1948, the midwest depot was closed and the tracks were moved west. The depot became a restaurant, was later torn down, and was eventually replaced by Bruce Boomsma's Lakeview Point Condominiums in 2001. (MD.)

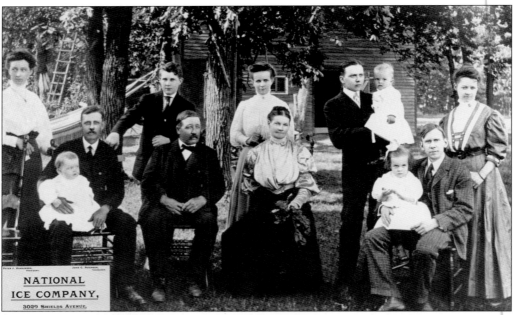

Peter J. Howkinson moved to Cedar Lake to farm ice in 1898. His National Ice Company was based in Chicago and was quite successful. This photograph was taken in 1907. Pictured here are, from left to right, Anna Herlitz Howkinson, Harry Howkinson (holding son Richard Howkinson), Martin Howkinson, Peter J. Howkinson, Ada Howkinson Turnquist, Christina Howkinson, Carl Turnquist (holding son Lawrence Turnquist), Jalmer Linquist (holding daughter Ada), and Florence Howkinson Linquist. (MAK.)

Peter J. Howkinson bought farms for his children. In 1925, the Magada dairy farm, located southwest of the lake and named after Peter's son Martin Howkinson; Martin's wife, Gasche; and their son David, included marshland for growing potatoes, turnips, corn, and soybeans. Marsh farming required removal of the water, and it was pumped over the road into the lake at Pine Crest Marina. Granddaughter Mary Alice Howkinson Koehler remembers running to turn on the pumps during a rainstorm. The swamp is now protected land. (MAK.)

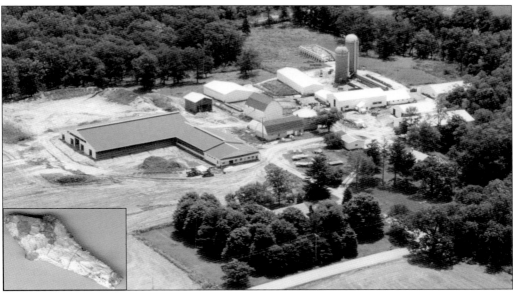

It was a sad day in the Howkinson home when the Monon tracks were moved west in 1948 because the new tracks bisected the farm. The Monon provided a tunnel for cattle to move across the property and a crossing for farm equipment. This is the Magada farm in 1993. Many arrowheads have been found on this farm. (MAK.)

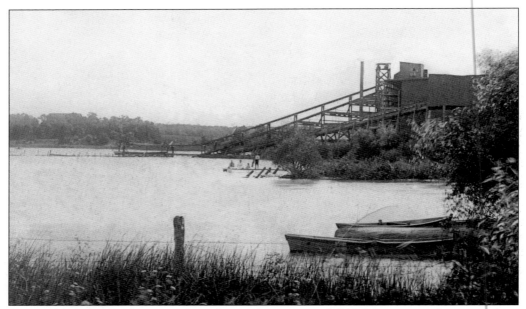

An ice elevator in Paisley is seen here during the summer of 1912. Many ice workers came from Chicago's Skid Row, bringing lice with them. Local men also worked the winter ice and returned to their regular jobs in the spring. Long, cold winters made good, thick ice. An average ice season lasted about six weeks. The elevators remained in place when the ice melted and boaters and swimmers accepted them as normal. (LRCM.)

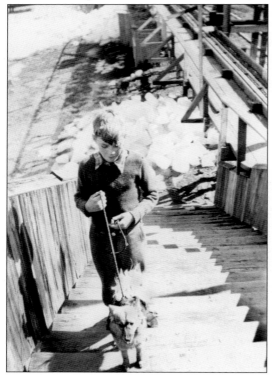

Dick Norris climbs the stairs from the lakefront to his family's home on the southern edge of the Moody Conference Grounds in the early spring of 1943. At the bottom of the stairs, to the right, is an ice elevator. What appear to be rocks next to the elevator is scrap ice. Ice was sold at specific dimensions, and when blocks did not meet specifications, they became scrap and were left to melt. (DN.)

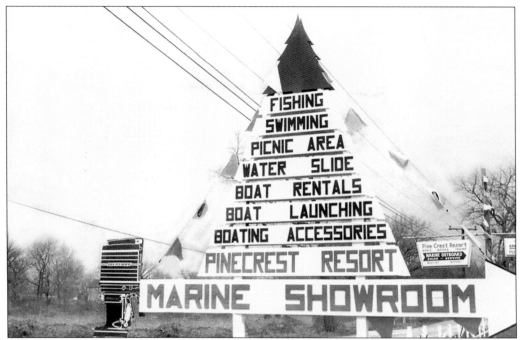

Clarence (Ted) Gross Sr. and his family bought a house in Cedar Lake in 1946. The house needed a lot of work and nearly shook its occupants out of bed when the train passed by on the lakeshore. Son Bob Gross built a rowboat in his high school shop class. He later made 35 more in his basement, and Pinecrest Resort was in the boat rental business. Bob and brother Clarence (Ted) Gross Jr. made this sign in 1961 to welcome vacationers. (TG.)

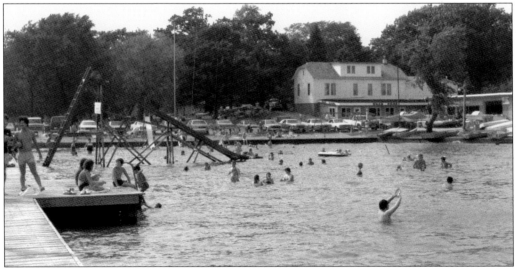

Pinecrest Resort is located on the former site of the Paisley train depot. The Snak Shak is attached to the Gross home at right. This was and is a popular place to buy, store, and launch boats and to picnic, fish, and swim. The stainless-steel slide—now gone—was great in the 1960s. Adjacent properties were bought, and the business grew. In recent years, LaTulip Harbor became part of Pinecrest Resort. (TG.)

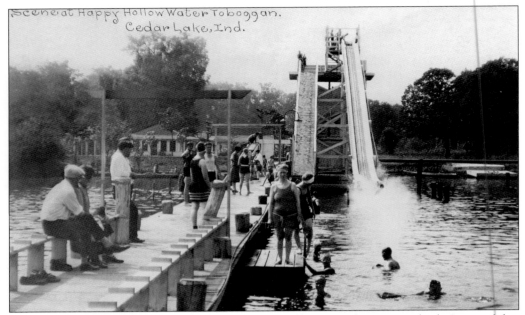

Scene at Happy Hollow Water Toboggan.
Cedar Lake, Ind.

To the north of Pinecrest was the Happy Hollow water toboggan, a forerunner of today's waterslides. Riders carried a wooden sled up the stairs and sat on the sled for the ride down and over the water. An old sled is in the Lake of the Red Cedars Museum, and it is very heavy. This photograph was taken in the 1920s, when bathing suits were similar to the short dresses of today. (ADS.)

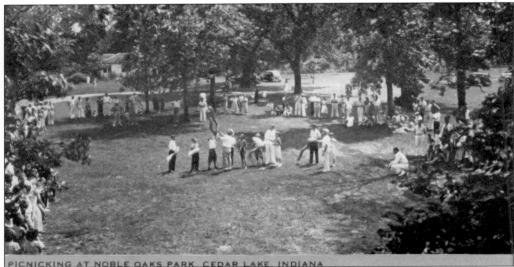

PICNICKING AT NOBLE OAKS PARK CEDAR LAKE INDIANA

John DuBreuil contracted with the Monon Railroad to build the DuBreuil Hotel in 1882. The DuBreuil acreage was sold to the Monon Railroad, became Monon Park, and attracted many tourists from 1882 to 1897. By 1910, the Anderson and Freeman Ice Company housed its workers in the DuBreuil Hotel, until it was torn down in 1920. Noble Soper bought the property, which became Noble Oaks Park and included a nine-hole golf course. Today, it is known as Noble Oaks Subdivision. (ADS.)

18

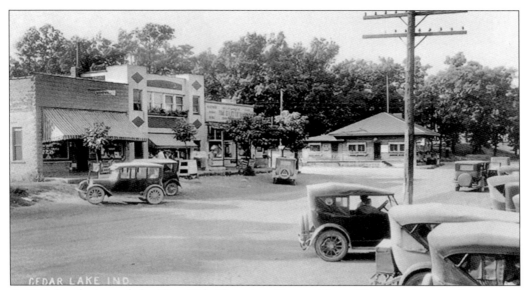

A 1914 fire decimated the West Side Shopping Center. Monte Biesecker bought the remains and restored the area. In this 1920s view of Biesecker Row, Soper Dry Goods Store is at far right. The dry goods store was later painted black and orange and became the Jack-O-Lantern Tavern, which was run by Frank Henn. During World War II, it became a church. It has been enlarged and remodeled, and today it is the Lighthouse Baptist Church. (ADS.)

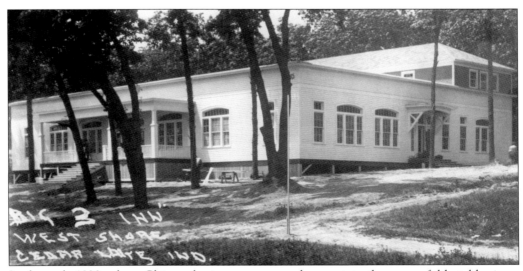

In the early 1920s, three Chicago businessmen wanted to get into the successful hotel business at Cedar Lake. They built the large Big 3 Inn south of the West Side Shopping Center. It had a large dance floor and a bar, with bedrooms on the second story. It did very well until the stock market crash of 1929 and burned down shortly thereafter. (LRCM.)

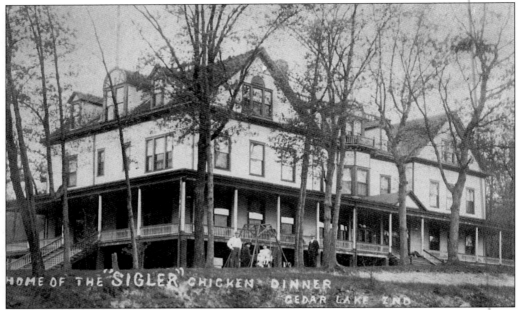

Charles Sigler managed the first Monon Park in 1898. He then built the Monon Hotel, also called the Sigler Hotel. The Monon train stopped here at 9:00 a.m. daily to pick up heavy cans of locally produced milk. The hotel was famous for chicken dinners. It burned down in 1914, and Monte Biesecker replaced it with a restaurant and pier managed by Bill Gerbing and Tobe Spindler. (LRCM.)

The Biesecker Pier, with the Monon water tower in the background, was managed by Cecil Mitch as Mitch's Pier in the 1930s. Then it was Casten's Pier, run by Pete and Pauline Casten. Pete kept the peace by carrying two revolvers on his hips. Dick Henn, Pete's son-in-law, said Pete never used them; he would just come up behind a rowdy patron and stand there, and that was all that was needed. (LRCM.)

Around 1970, Charles and Margaret Van Horn took over Casten's Pier and ran it as Chuck's Pier. The pier was a popular fishing spot. Local fisherman William Heintz remembers that as a boy he had to wait for someone to leave before he could find a spot to drop his line. But business slowed, and after nearly 85 years, the aging pier was torn down in 1999. This 1991 photograph is from the Van Horns' 50th wedding anniversary party. (LVH.)

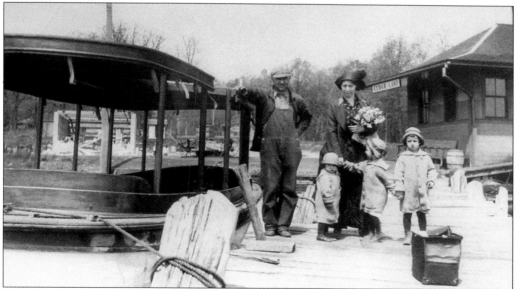

Walter F. Raubolt, DDS; his wife, Edith, and their sons Walter, William, and Wesley spent weekends at their home on Sherman Street in the Shades I Subdivision. A 1920s car trip from Chicago took four and a half hours. The day this photograph was taken, they took the train, which was faster. On the depot pier, the boat driver is about to help Edith and the boys board the *Nancy A* excursion boat, owned by George Hetzler, for the trip. Walter is likely the photographer. (LRCM.)

A bit of the Armour Ice House roofline is visible in the background, to the north of the lake. The train tracks run past dense woods with just a single house on the hill to the left in this early-1900s photograph. The shoreline was marshy and the water, being spring-fed, was very clear. An 1834 government survey referred to this body of water as Clear Lake. (LRCM.)

Chuck Van Horn bought the center home in early 1947. The train tracks were located at the bottom of the hill for another two years, with a fence between the tracks and the houses. When the Monon moved the tracks west in 1948, Monte Biesecker bought the Monon right-of-way. Van Horn and neighboring homeowners purchased the right-of-way in front of their homes from Biesecker, which gave them lakefront property. This photograph was taken in 1999. (LVH.)

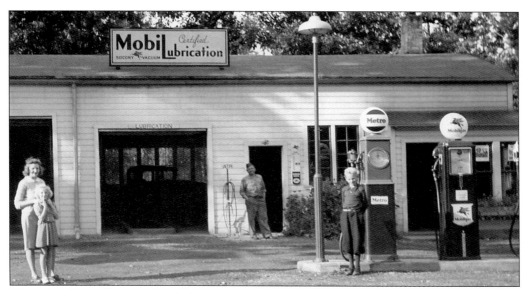

Chappell's Super Service opened in the late 1930s, a block up the hill from the depot. Pictured here are, from left to right, Annabelle Woolcott, Barbara Chappell, Barney Chappell, and Bruce Chappell. The photograph is dated September 1940. In 1942, Barney Chappell helped organize the first Cedar Lake Fire Department and had one of the first emergency sirens in his garage. Woodburn Auto Repair later occupied the building. The building has had several occupants. (LRCM.)

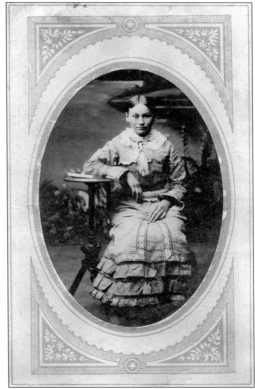

The first Monon Park became overcrowded and a second Monon Park was opened in 1897 on 20 acres, about a quarter mile north of the first park, on the southern border of Armour Town. Calliopes played, dice were thrown, and vendors sold Cracker Jack and popcorn. Eastman Kodak set up a booth to sell souvenir photographs. This tintype, identified only as Horner, was a nearly instant photograph applied to a thin sheet of metal and set in a paper frame. (LRCM.)

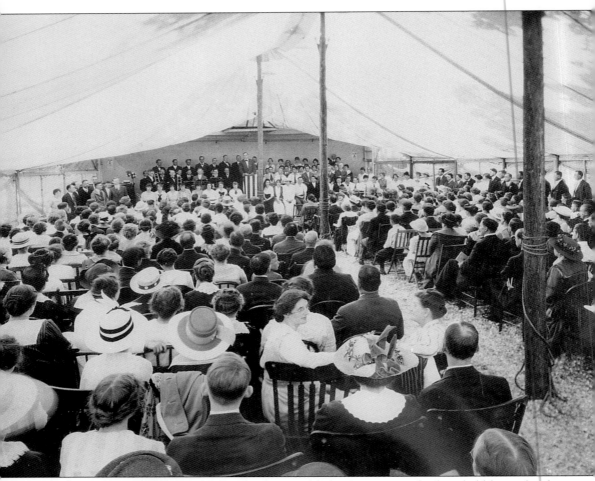

Marshall Field and Company, the plumbers' and bakers' unions, and others held large, family-oriented picnics at the second Monon Park. But others came to drink, gamble, and cause trouble; the Chicago bartenders' picnic was really wild. On the return trip to Chicago, the bartenders became so unruly that the train crew disconnected their car in Hammond and left them there. In 1914, Rev. E.Y. Woolley, pastor of Moody Church in Chicago, took a trip on the train, stopped at the park, and envisioned a retreat on the site. He approached Frederic Delano, president of Monon. Delano was anxious to be rid of the park. A contact was created, stating that if Moody cleaned up the park, paid the taxes and insurance, and guaranteed constant traffic on the train, the Monon Railroad would give the park to Moody Church in five years. Moody fulfilled the responsibilities, and the Monon honored the contract. In the 1920s, conference attendees—between 400 and 500 people per day—sat on wooden folding chairs under huge canvas tents. (LRCM.)

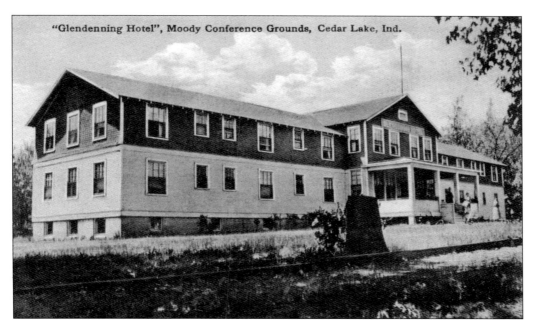

"Glendenning Hotel", Moody Conference Grounds, Cedar Lake, Ind.

Many who came to the Moody Conference Grounds from Chicago needed overnight accommodations. Robert Glendenning built the Glendenning Hotel on property south of the grounds and allowed Moody to use it. The building was later donated to Moody, cut into pieces, rolled through the woods on logs, and reconstructed on the conference grounds' tent site. In 1935, the hotel was lost to fire and was replaced two years later with Hotel Rest-A-While. (MS.)

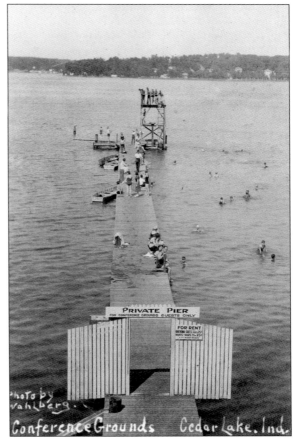

During the Depression years, a vacation at Cedar Lake was a luxury. Families spending a summer week at the Moody Conference Grounds had a great time. The children especially loved days of fishing and swimming. The sign at right reads, "FOR RENT: Bathing suits two hours 25¢, Boat and oars one hour 25¢, $1 deposit on oars." This postcard is dated 1931. (MS.)

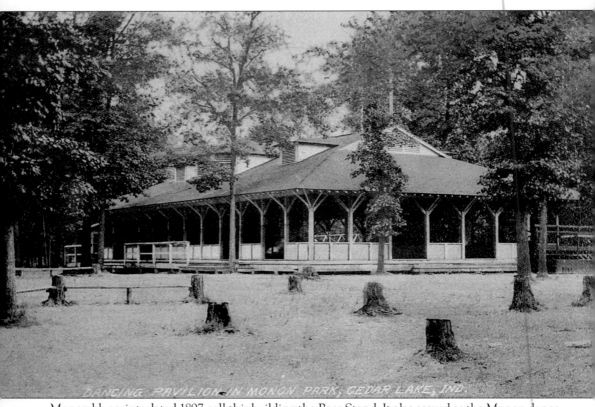

DANCING PAVILION IN MONON PARK, CEDAR LAKE, IND.

Monon blueprints dated 1897 call this building the Beer Stand. It also served as the Monon dance pavilion with music provided by big name bands of the day while patrons danced the fox-trot, waltz, and Charleston. In the early days of the Moody Conference Grounds, it was called "The Lodge" and used as a dormitory, with thin wood partitions for walls. Mostly, it has served as a church meeting place. In 1959, it provided ministry through Saturday night concerts and Tuesday movie nights. Pastor Harry Beamer remembers Billy Graham preaching here around 1945. In the 1920s, the building was renamed Torrey Hall after evangelist Reuben Torrey. It is in the National Register of Historic Places and currently hosts the weekly Sunday services of Faith Church. The grounds have gone through different names and different owners, major building renovations, and land acquisitions and survived. A 75-year anniversary celebration was held in 1990, and Moody Conference Grounds, now called Cedar Lake Ministries, continues in 2011. (LRCM.)

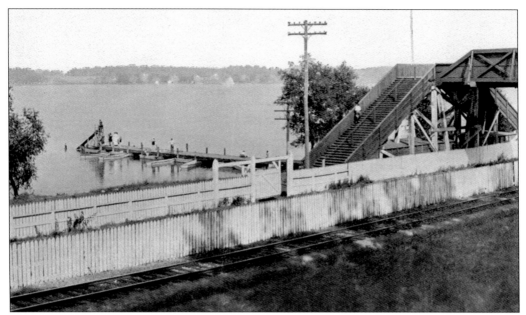

This walkway crossed from the third depot, called Cedar Lake, over the railroad tracks. Visitors walked along a path to the second Monon Park, which later became Moody Conference Grounds. The tracks were removed in 1948. The walkway was dismantled and the wood used in construction projects at Hotel Rest-A-While, South Gate Chapel, and Moody Bookstore on the conference grounds. The conference grounds acquired lakefront property by purchasing the vacated railroad right-of-way. (MS.)

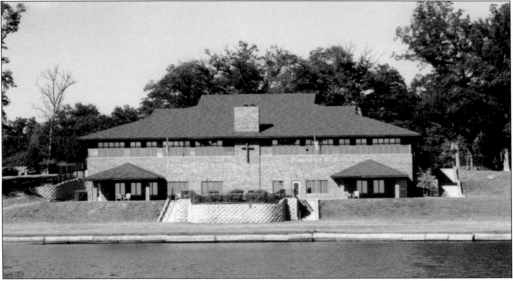

Monon train tracks along the lakeshore are gone, and this Cedar Lakes Ministries dining hall, built in 1996, provides meals and a great view for visitors. The Monon Railroad built Needham Hall in the early 1900s, north of the dining hall site. Needham was renamed Lakeview Lodge, remodeled, and currently provides visitor lodging. Lakeview Lodge and Torrey Hall are the only structures still standing that were built by the Monon Railroad. (MS.)

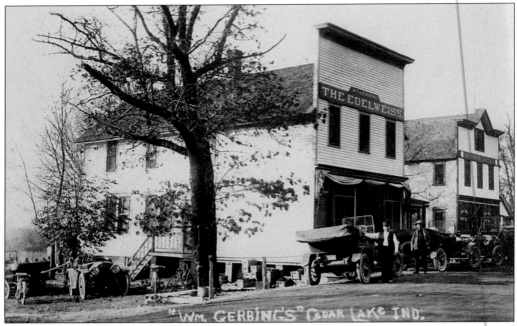

William Gerbing built this combination home and saloon around 1900. Tourists arriving at the Cedar Lake train depot walked approximately a block west and up the hill to the Gerbing Saloon and the Einsele Hotel next door. The Edelweiss sign refers to the brand of beer sold there. A long line of hitching rails stood in front of Gerbing's and Einsele's until automobiles became popular. (LRCM.)

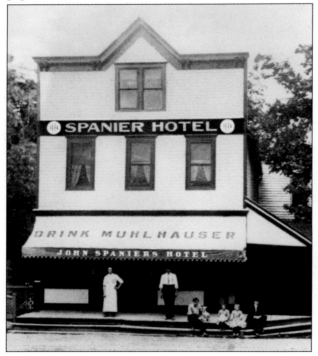

Sebastian Einsele built the Einsele Hotel in 1898. John Spanier took over in 1908, followed by John Stasitis from the 1920s to 1955. Stasitis called it the Cedar Beach Hotel, and he was famous for an annual Fourth of July party with free chop suey for everyone. Next, it was the Hanover House, owned by Louis Wislocki. In 2004, the Cedar Beach Arts Center moved in. The building still stands at 13930 Lauerman Street. (LRCM.)

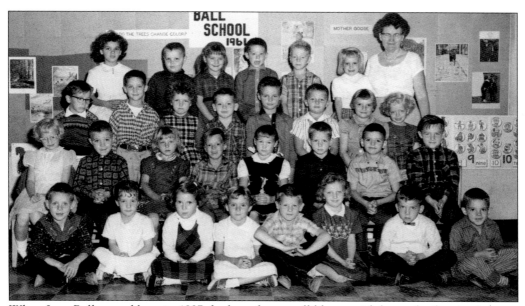

When Jane Ball moved here in 1837 she brought a small library with her—the first in the area. She was an educated woman who taught in a log school located northwest of the lake. The current Jane Ball Elementary School, which opened in 1957 at 13313 Parrish Avenue, is named after her. Marion Norris raised her children, then returned to school for a teaching degree. She is the teacher pictured at top right in this 1961 photograph of a class at the Jane Ball Elementary School. (DN.)

The Airline Drive-In was located at the southeast corner of 133rd and Parrish Avenues in the 1940s. The space had many tenants before George Poponas opened the Cedar Lake Kitchen there in 1998. In the early 2000s, David L. Ross, better known as Lieutenant Galloway from *Star Trek*, lived in Cedar Lake and ate at the Cedar Lake Kitchen. The new Cedar Lake Kitchen opened at 10325 West 133rd Avenue in spring 2011. (GP.)

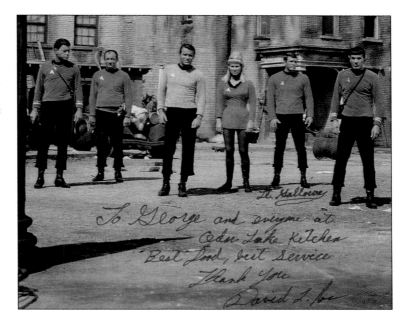

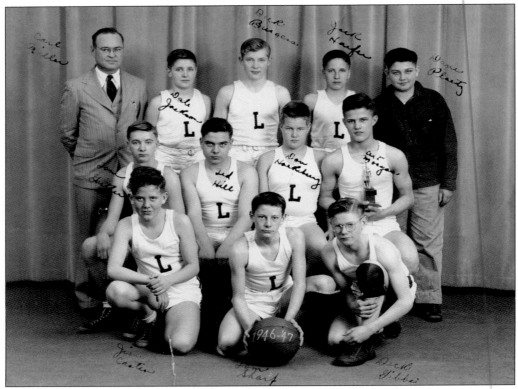

Lincoln School's 1946–1947 basketball team is shown here. The players are, from left to right, (first row) Jim Casten, Tom Short, and Dick Gibbs, (second row) Tom Gaither, Ted Hill, Don Horkeburg, and Art Morgan, (third row) coach Carl Miller, Dale Jackson, Dick Burgess, Jack Harfer, and Dave Ploetz. Lincoln School replaced Armour School in 1912. Classes were held at the northwest corner of 133rd Avenue and Parrish Avenue until 1991. Lincoln School is now located at 12245 West 109th Avenue. (LRCM.)

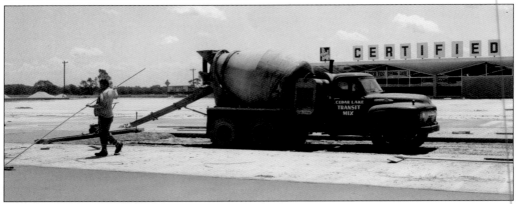

Martin and Raymond Mager developed farmland into the Utopia Subdivision in the 1950s. They also developed Lincoln Plaza, on the southwest corner of 133rd Avenue and Parrish Avenue with a bank, appliance store, Certified Grocery, and Ben Franklin. They built the grocery store themselves, and it was recognized in 1972 for its unique concrete construction. Jeff Bunge added Cedar Lake True Value Hardware in 1970. (PCRP.)

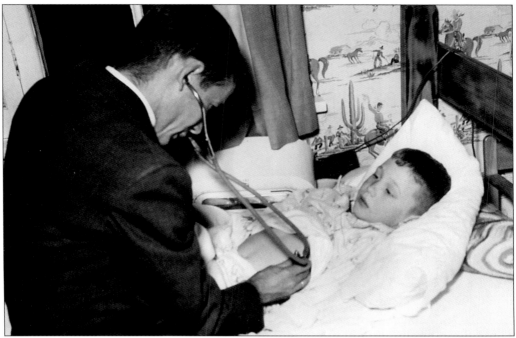

Dr. Robert W. King's office was built at the northeast corner of the Lincoln Plaza in 1970. This photograph was taken at a house call. Dr. King's son Edward King said that he and his siblings took turns riding along on house calls and waiting in the car. Dr. King is considered by many to be the father of Cedar Lake because of his involvement in the town's incorporation. (LRCM.)

Summer cottages became permanent dwellings during the Depression. But cottage septic systems could not handle the load, overflowing and polluting the lake with sewage. Dr. Robert King organized residents to incorporate the town. An incorporated town could receive federal assistance to install sewers. Incorporation was achieved in 1965 but was overthrown in 1967 on a technicality. On September 9, 1969, the Indiana Supreme Court upheld the incorporation. (TG.)

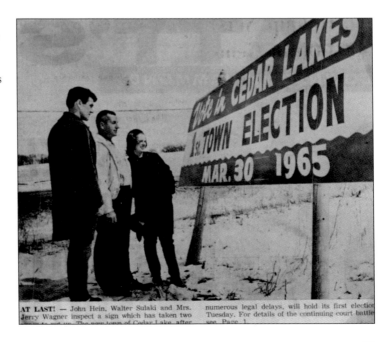

AT LAST! — John Hein, Walter Sulaki and Mrs. Jerry Wagner inspect a sign which has taken two ~~ ~~ ~~ The new town of Cedar Lake after numerous legal delays, will hold its first election Tuesday. For details of the continuing court battle see Page 1.

The 1880 post office started in Creston and moved to the Paisley Depot, the Armour Depot, several hotels, a few homes, and different buildings on Biesecker Row. Twelve-year-old Henry Henn delivered mail on horseback around 1900. Mailman William Stoll delivered 50 chickens on Route 1 in the 1950s. The post office has been at 9715 West 133rd Avenue since 1964, with a rural contract station at 7212 West 133rd Avenue. (CO.)

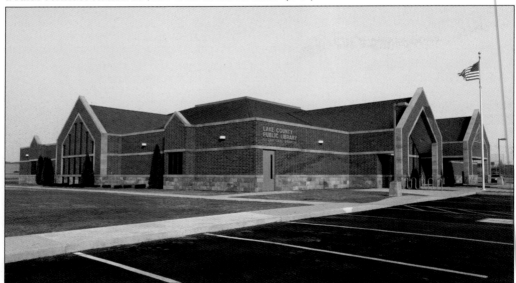

Cedar Lake's library began in 1939 with a bookmobile. A location in Biesecker Row opened later for three days per week. In 1962, Martin and Clara Mager donated part of the land for a library at 13330 Parrish Avenue in the Lincoln Plaza; the old library is the current office of the Hanover Township Trustee. In 2006, the library pictured above, part of the Lake County Public Library System, was built at 10010 West 133rd Avenue. (CO.)

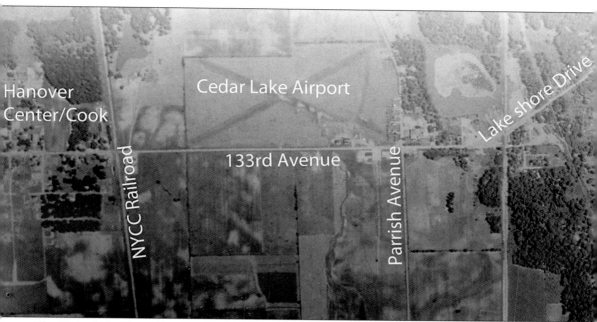

The Cedar Lake Flying Service ran the Cedar Lake Airport from the late 1940s to the early 1960s. Pilots at the private airport gave air tours of the area. Jimmy Kubal gave flying lessons. Cedar Lake Animal Hospital used to be a hangar, and Dr. Dave's Ouch Ink Tattoo Shop and Goldie's Auto Body II also used to be airport buildings. A 1956 tornado destroyed other structures. The Mager family donated airport land to the Hanover Community School Corporation, and the high school was built in 1965. The airstrip became the athletic track. Students chose the school name, and in the final vote, Hanover Central beat out Lincoln. A junior high wing was added in 1971. The first graduating class of 1968 included Harry Beamer and Bonnie Gudmundson (later Beamer). Gudmundson was the first graduate to return as a teacher in 1975, and she is still there in 2011. Hanover Township residents attend Hanover Central. Center Township residents attend Crown Point High School. Students in the 1960s enjoyed a go-kart track across from the present-day CVS Pharmacy. The Burger King area was the Golfatorium—a miniature golf and driving range. The photograph is from the late 1940s. (PCRP.)

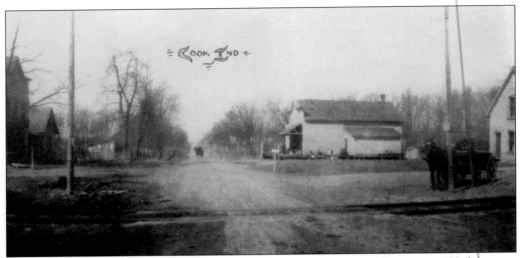

Looking west in 1905, the New York Central Railroad tracks cross over Adeway, now 133rd Avenue. This western edge of Cedar Lake was founded as Hanover Center in 1855. Shown here are, from left to right, the Hein Hotel, Lauerman Store, and Nichols Grain and Hay. (RF.)

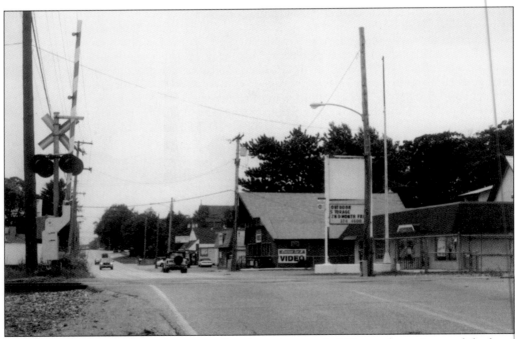

This 2002 photograph shows the same railroad crossing nearly 100 years later. Automobiles have replaced horses and buggies on 133rd Avenue. Videos were unknown in 1905, but common in 2002. Railroad crossing signals have been installed. (LRCM.)

Nichols Grain and Hay Company sat west of the railroad tracks and north of 133rd Avenue. Farm products and livestock were brought here, then shipped on the train. The grain elevator stood from 1906 to 1945. Wilbur Lumber operated here in the 1920s, followed by Cedar Lake Building and Salvage into the 1980s. Bumper to Bumper currently occupies the site. The huge drive-through lumber house still stands in the back. (ADS.)

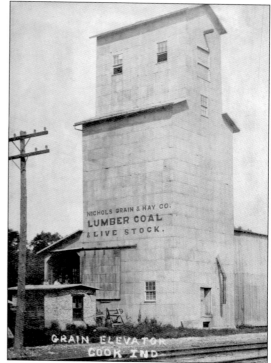

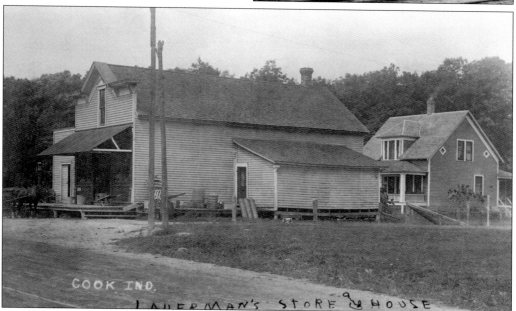

Matthias M. Lauerman ran the Lauerman General Store in Armour Town in 1896. Son Arthur Lauerman moved half the store to Cook in 1908 and added the rear house in 1910. Another son, Edward Lauerman, moved the other half of the store west of the lake, near the Gerbing Saloon, and opened Ed. J. Lauerman General Store. In 1918, Edward moved the building again, to Cook, and joined his store with Arthur's store. (LRCM.)

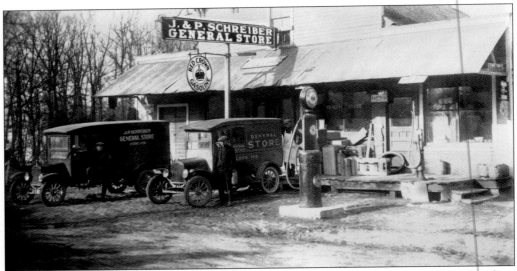

In 1920, Lauerman's Cook store was sold to Henry Paulus and sold again in 1924 to brothers John and Peter Schreiber. Two enclosed delivery trucks made daily rounds in Cedar Lake and neighboring towns. In the 1920s, Red Crown gasoline pumps were added. (LRCM.)

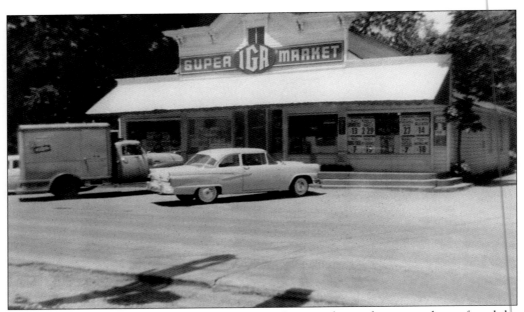

In 1953, John and Peter Schreiber built a new IGA Supermarket to the west and transferred the store's stock to the new building at 10728 West 133rd Avenue, which is now the Gateway Christian Fellowship. The structure across the street was home to the Hein Hotel, Cook's Lounge, and Cook Gardens before the building burned down. That area, at 10711 West 133rd Avenue, is now developed as Homescapes Garden Center. (ADS.)

Jacob A. Weiss opened a blacksmith shop in the new village of Hanover Center around 1856. The shop was a center of commerce in pioneer times. Apprentice John Schillo took over the shop in 1877. Michael Schillo joined his father in the business, which they ran until 1912. This is the undated wedding photograph of Michael and Barbara Schillo. (LRCM.)

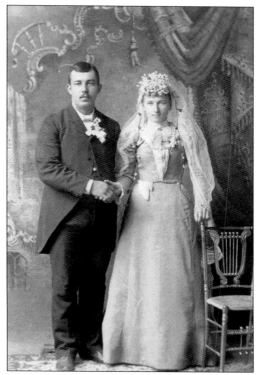

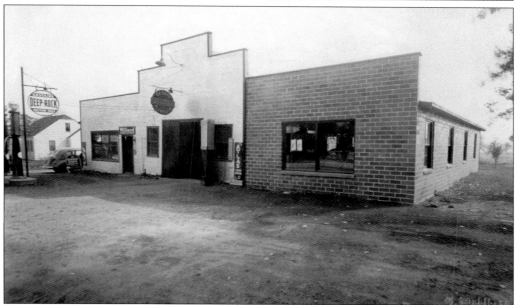

The owners of the blacksmith shop from 1912 to 1925 are unknown, but it was put up for sale in 1925. John Adam Schutz bought the property and converted it into an auto repair shop called Center Garage. He worked here from 7:00 a.m. to 9:00 p.m., seven days a week. Weekend tourist traffic provided a lot of business in replacing flat tires and cooling overheated radiators. The central part of the building was where the blacksmith shop was located. (JS.)

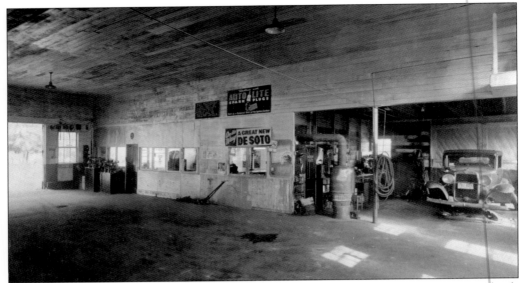

This is the garage interior—with a DeSoto—in the 1930s. Schutz sold Fords and Willys-Overlands and added Chryslers in 1934. The Depression was bad, as customers paid only 50¢ a month on their bills. During World War II, few cars were sold and people turned in mountains of old tires for the war effort. Son John Nicholas (Jack) Schutz started work in 1940 and son-in-law Gene Buszek joined the company in 1953. (JS.)

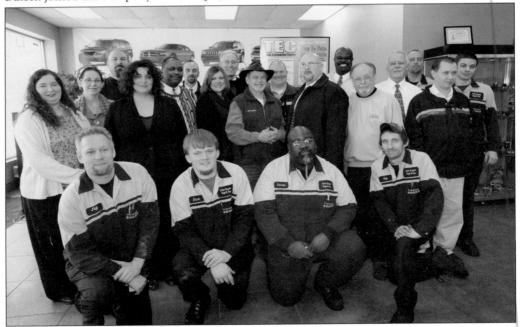

Grandson John Gregory (Johnny) Schutz joined the team in 1971. The garage burned down in 1989 and was rebuilt off the road in anticipation of a widened roadway. John Schutz's Center Garage has been in business for 86 years and is the town's oldest establishment. Tom Vicari is the current manager. This staff photograph was taken on February 1, 2011, a few hours before a blizzard dropped two feet of snow. Johnny is standing in the center, wearing a hat. (CO.)

Before 1852, Catholic Mass was held in the home of Johanna and Matthias Geisen. In 1859, Geisen donated land for a church, and St. Matthias Catholic Church was built. It later burned down in 1866. A new frame building, measuring 36 feet by 66 feet, was constructed in 1868 and called St. Martin's Catholic Church. Geisen donated three large church bells. In 1913, the bells were placed in a new stone structure that served until 1930. (LRCM.)

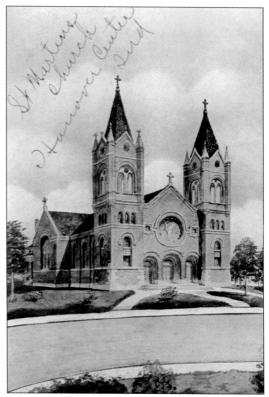

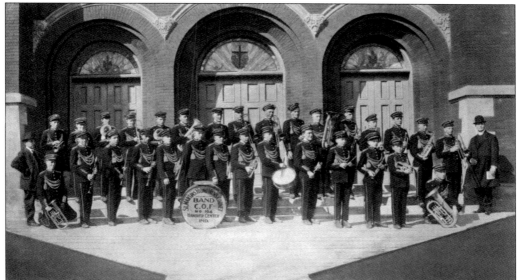

St. Martin's Young Men's coronet band C.O.F 104 poses in front of St. Martin's Catholic Church around 1920. Fr. Herman Juraschek organized this band with support from the Independent Order of Foresters, a fraternal benefit society. The band wore green uniforms and played all over the surrounding area. The church served parishioners well until it burned in 1930. People ran down 133rd Avenue carrying buckets filled with water, but the church was completely destroyed. (LRCM.)

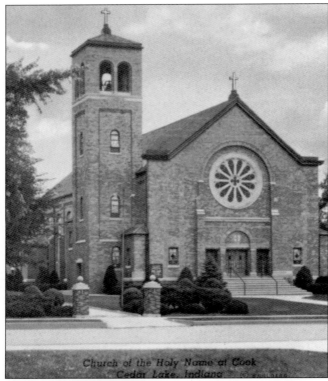

Church of the Holy Name at Cook
Cedar Lake, Indiana

In 1932, a new cornerstone was laid and a basement was built to hold services while money was being raised. The upper portion was completed in 1940 and called Holy Name of Jesus Catholic Church. The John Schutz family donated the rose window above the choir loft. Lightning damaged the bell tower in the 1970s, and it was removed in 1985. The church is located at 11000 West 133rd Avenue. (LRCM.)

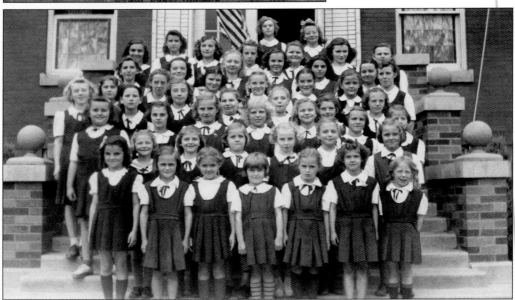

St. Martin's Catholic School was dedicated on August 4, 1912. The brick building had nine grades in three rooms. German and English were taught until World War I, when the United States was at war with Germany and the German class was dropped. These St. Martin's girls were photographed in 1942. A new building was constructed in 1956, and the name was changed to Holy Name School. After 30 years of instruction, the school closed in 1986. (LRCM.)

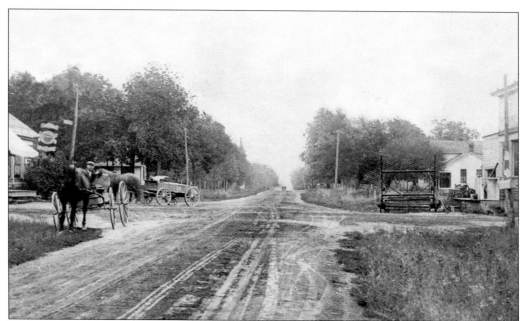

This 1913 image shows the intersection of Route 41, which runs left to right, and Adeway (now known as 133rd Avenue). Looking east, the steeple of St. Martin's Catholic Church is just visible above the trees to the left of the road. In the 1870s, Lorenz Bixenman built the home and saloon on the northeast corner (at left). The Frank Massoth home and store sit on the southeast corner (at right). (LRCM.)

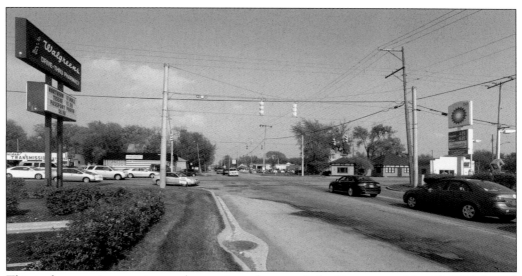

This is the same intersection as the previous photograph, looking east on May 10, 2011. In 100 years, pavement, stoplights, and automobiles have all been added. Businesses in the present-day area include Gerstenkorn Family Chiropractic, Doug Komo's Meat and Deli, McDonald's, Walgreen's, Harry O's Restaurant, Lake Liquors, Sprint, Alice Wright Realty, Century 21 Realty (formerly the White Swan Restaurant), Widco Transmission, and Sims Realty (formerly the Bixenman home). Regular gas on this date cost $4.25 a gallon. (CO.)

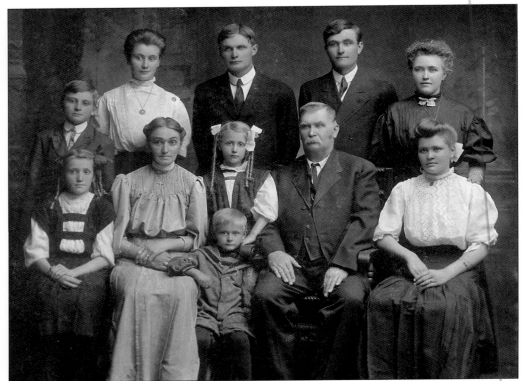

This Schafer family photograph was taken around 1905. The family members are, from left to right, (first row) Marie Schafer Saur, Mary Massoth Schafer, Margaret Schafer Bixenman, Frank Schafer, Nicholas Schafer, and Ida Schafer Bixenman; (second row) John Schafer, Catherine Schafer Kenning, Adam Schafer, Henry Schafer, and Matilda Schafer Kenning. In 1912, Adam Schafer owned the old Massoth Store, where he sold farm implements. He built Hanover Center's first gas station there around 1920. (IUN.)

Adam Schafer also sold new Fords for $350 on this southeast corner of Route 41 and Adeway. Schafer's wife, Lena, ran a restaurant and later a kindergarten in the building to the south. In 1978, Wolfgang Johann Mees rented the property, converted the station to an office, and sold Farmers Insurance. Daughter Heidi Mees-Duncan joined the business and moved the Farmers Insurance office to 13115 Wicker Avenue in 2006. (HM.)

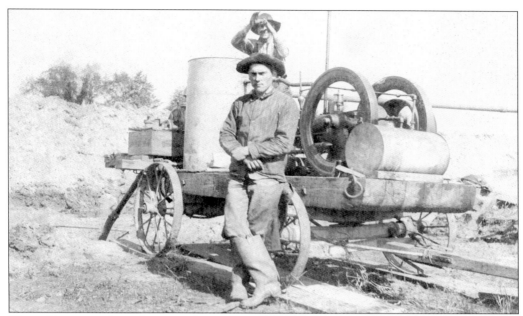

Henry Henn, seen here, began work as a contractor in 1908, building many houses in the Cedar Lake area. Henn and brother Raymond Henn formed Henn and Sons Construction in 1937. Son Richard (Dick) Henn, and now grandson Robert Henn, have joined the business. The Henn and Sons Construction building, at 13733 Wicker Avenue, was erected in 1992. The Henns work with Sheehy Well & Pump Co., Inc., located at 15530 Wicker Avenue, which has provided well services since 1939. (DH.)

In 1946, three acres were bought for $850 from Carl and Frank Scott to build a church. Community Bible Church services started in 1948. The church has grown since then. In August 1982, this peak roof was added over the vestibule. Jim Watt donated acreage for expansion. The church is located at 13620 Wicker Avenue and led by Pastor Ric Eddings. (CO.)

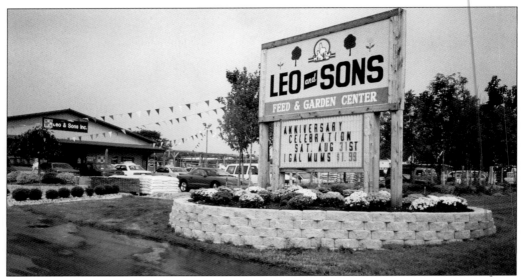

Leo Govert started his business in 1978 on Wicker Avenue, in the present-day location of R. and C. Small Engine Repair. Son Steve Govert joined the venture in 1989, purchased Miller's hay field, and built Leo and Sons, Inc., at 13406 Wicker Avenue. Yancey's House of Carpet opened next to Govert's first store. In 1992, Rich Yancey built a new store at 13408 Wicker Avenue. Daughter Linda Yancey Sharp is now a partner. (SG.)

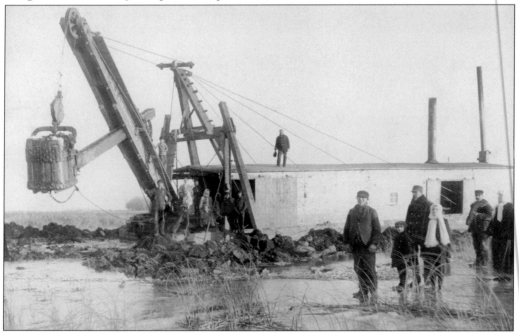

This Kretz-owned dredge drained the marshlands of south Cedar Lake in 1870. There is no additional information on the photograph. The Phillip Kretz family farmed Hanover Center land east of Route 41 beginning in 1852. Grandson Frank Kretz, with sons Don and Jim Kretz, ran Kretz Equipment from the 1960s to 2010. Arnold and Ann Kretz owned the property at the southwest corner of Route 41 and 133rd Avenue, currently a BP gas station. (IUN.)

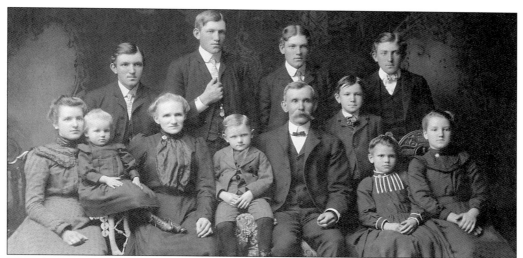

This photograph is identified as the Gard family. This family is another name in Cedar Lake history, though details are few. Nicholas Gard farmed on the north side of town in the early 1900s. Son Elmer Gard opened his first Laundromat on Route 41 in Cedar Lake around 1961. At one time, Gard had seven Laundromats around the area. Grandson Donald Gard still owns Gard's Laundry and Dry Cleaning at 13212 Wicker Avenue. (LRCM.)

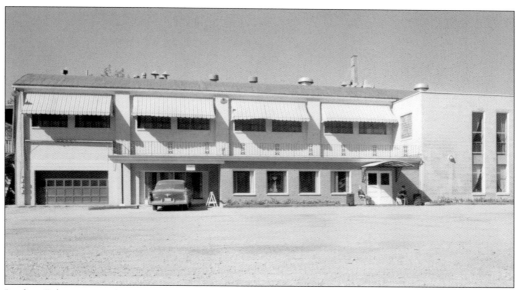

Lothar Ederer owned R.J. Ederer Company, a successful net manufacturing business on Orleans Street in Chicago. He had contracts with George Pullman, Florida shrimp fishermen, and the US government. World War II increased demand for camouflage netting, and Ederer needed another facility. He bought this building in Cedar Lake and outfitted it, but the war ended. In 1956, Ederer started a new company called Great Oaks Poultry and tested chicken feed in other buildings on the property. (TMA.)

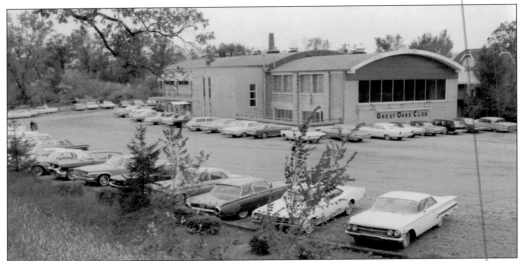

Ederer remodeled the factory and incorporated the After 4 Club in 1960. His health club, one of the first in the area, included a workout room, sauna, tanning beds, and a masseuse. That building became the Great Oaks Club and is now Great Oaks Banquets at 13109 South Wicker Avenue. The ballroom's crystal chandelier still hangs over wedding receptions and weekly dinners in the banquet hall. (TMA.)

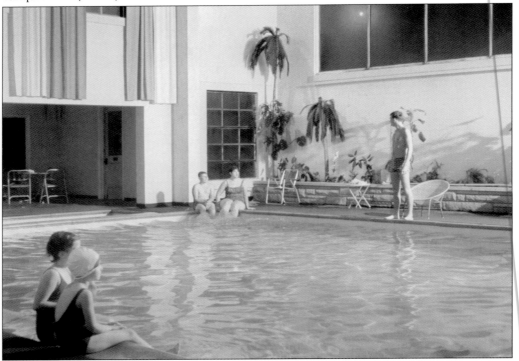

The health club included this indoor pool. The second-floor dining area to the left and bar to the right overlooked the pool. A 1995 storm destroyed the pool roof. It was rebuilt, but modern clubs came to the area and the pool was filled with concrete in 1997. The L'arc en Ciel Theatre Group developed the area over the pool and began performing there in 2005. (TMA.)

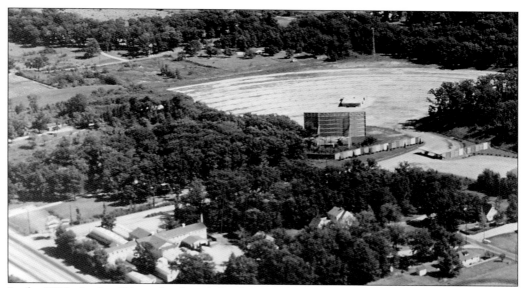

In the 1950s, Lothar Ederer developed the Great Oaks Auto Theatre, which showed a variety of movies. All these enterprises made Ederer and his wife, Harriet, quite wealthy. But after Ederer died in 1977, Harriet could not manage everything. The Great Oaks Auto Theatre was rented, and the new manager showed pornographic movies. This created an uproar in town, and the theater was forced to close in 1983. The screen is now gone. (TMA.)

Harriet and Lothar Ederer pose by Great Oaks Manor Convalescent Home, a 1950s development. The nursing home was torn down in the mid-1970s and replaced with Great Oaks Plaza, owned by Larry Coffin and Dick Henn. Current tenants are Dagwood's Sandwich Shoppe, H.P.S. Cabinets, Kitchens by Merrillatt, Illiana Eyecare, Farmers Insurance, Head Games Salon, and Jackson Hewitt. The original acreage was sold in sections. Tom McAdams still owns Great Oaks Banquets on three acres. (TMA.)

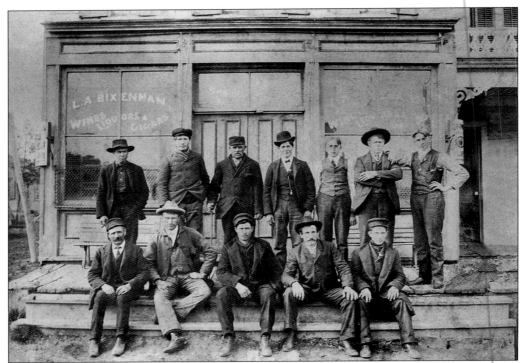

Lorenz and Elizabeth Bixenman built a combination home and saloon on the northeast corner of Route 41 and Adeway around 1870. This photograph of Hanover Center men on the front porch is dated 1905. Son Emil Bixenman grew up in this home. Emil married Ida Schafer. They remodeled the old corner building and ran a grocery store and meat market. Currently, this location is home to a seasonal supplier of fireworks. (LRCM.)

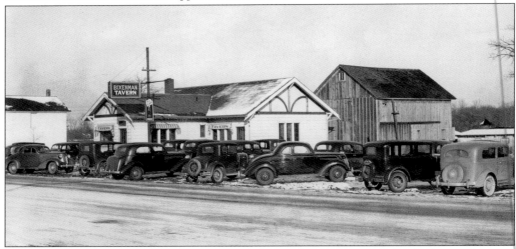

Joseph and Bertha Bixenman built a tavern to the north on Route 41. It has had several names: Saco's, Silver Dollar Tavern, Antoinette's, and now Carlo's Pizzeria. This picture is from around 1937. The 100-year-old home behind the tavern was built using wood from the dismantled St. Martin's Catholic Church, which served as a school and a convent; current tenants tell of hearing unexplained footsteps and laughter. (WS.)

Two

NORTH SIDE

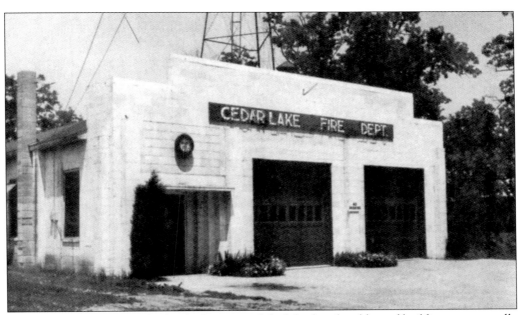

Prior to 1942, bucket brigades fought fires around the lake, but the old wood buildings were usually destroyed. On October 7, 1942, Charlton Rattray, Joe Kralek, Harry Howkinson, Cordie Coffin, Barney Chappell, George Robertson, Matt Lauerman, and O.C. Granger met to form the Cedar Lake Fire and Protective Association. Nicholas Mager donated land, funds were raised from the community, and a volunteer fire department began in this building. (ADS.)

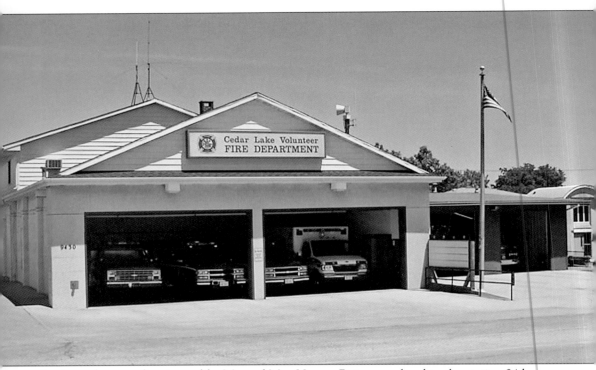

In the early years, fire sitters, like Mr. and Mrs. Vetrees Rainwater, lived in the station 24 hours a day, seven days a week. In return for room and utilities, they answered calls and tripped the fire alarm. This was the only house with a fire engine in the garage! The alarms rang at the fire station, Center Garage, Happy Days Bait and Supply, and Chappell's Super Service. In the 1970s, volunteers began carrying pagers or radios. The original building at 9400 West 133rd Avenue, shown here in 2006, has been updated and enlarged. The building at far right was originally the First Baptist Church, which moved to 13419 Parrish Avenue, and the old church building is now a fire training facility. Three ambulances with trained EMTs, a ladder truck, pumper/tanker, brush truck, rescue truck, ATV, rescue boat, and dive trailer have replaced bucket brigades. The first fire chief was Charlton Rattray, followed by Frank Mitch, Martin Saberniak, Vernon (Smokey) Bixeman, Robert Eberle, and Dennis Wilkening. The current fire chief is Todd Wilkening, Dennis's son. (CLFD.)

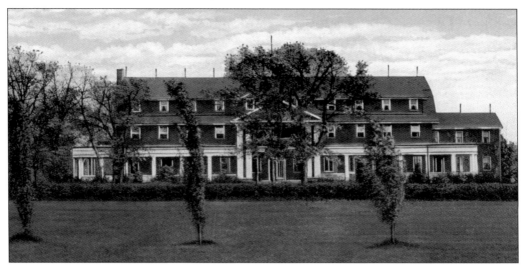

Pioneer John Rhein raised hogs on his farm. In 1912, a cholera epidemic struck the herd and Rhein buried about 50 hogs in the marsh, which is now the site of a beautiful pond. Son Joseph Rhein with his wife, Lena, continued farming until 1926, when George Einsele purchased the farm and built this Einsele Hotel. Einsele hired carpenter Nicholas Mager and bricklayer William Bierieger as the contractors. (ADS.)

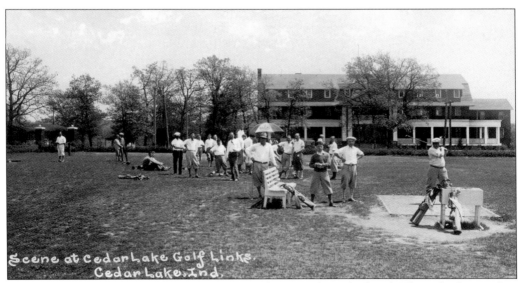

Einsele developed an 18-hole golf course across the street from the hotel. The *Lake County Star* advertised a full day of golf at the Cedar Lake Golf Links for 50¢ on weekdays and $1 on Sundays. A steak dinner in the Club Café was served for 75¢ to $1. The specialty chicken plate dinner was offered for 50¢. This photograph was taken about 1929. (SB.)

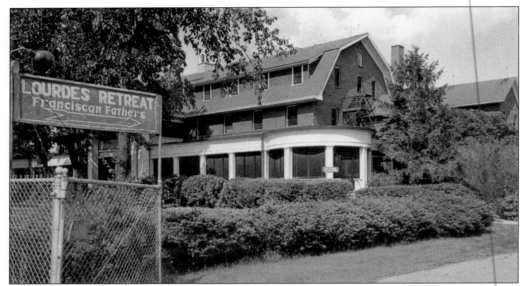

The Einsele Hotel had a first-floor kitchen, dining room, and common areas for socializing. The second and third floors had 10 rooms each. But the Depression hit, business slowed, and Einsele sold 175 acres, the hotel, and the golf course to the Order of Franciscan Friars. In 1938, the hotel on County Road K, now Parrish Avenue, was dedicated as Lourdes Friary. (RF.)

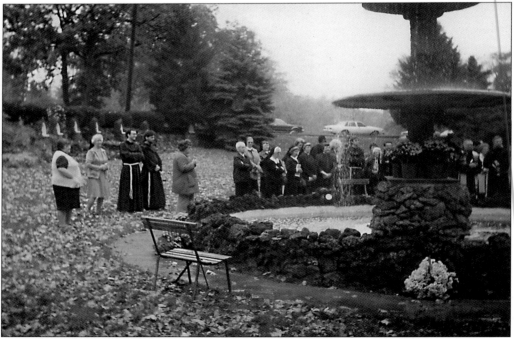

The golf course continued until the mid-2000s and was later sold. Part of that property was developed with homes in the Monastery Woods Subdivision. The fountain on the monastery grounds was refurbished and dedicated at the 1985 ceremony pictured above. The upper house, Lourdes Retreat House, is currently a residence for priests and is located at 12915 Parrish Avenue. The lower house, San Damiano Friary, was a home for novitiates. Visitors are welcome. (BC.)

Caesar and Joan Andreotti adorned their Lincolnshire Estate on Parrish Avenue with huge fiberglass giraffes. While dredging the pond in 1980, a piece of equipment uncovered this 75-pound bone. Here, Caesar poses with the find. It has been verified as an approximately 10,000-year-old mastodon bone and is displayed at Lake of the Red Cedars Museum. The Keith Eenigenburg family has owned the estate since 2001. (LRCM.)

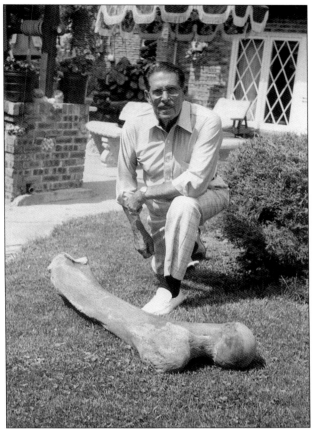

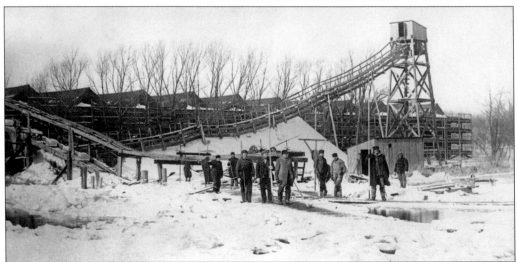

Before refrigerators, ice was used to keep food cold, and ice farming involved cutting ice from the lake. Horses pulled a heavy ice plow over the ice to cut blocks into 22-inch-thick squares. These men used an ice hook to guide the blocks of ice through channels cut in the ice, to the elevators, and into the storage barns. (LRCM.)

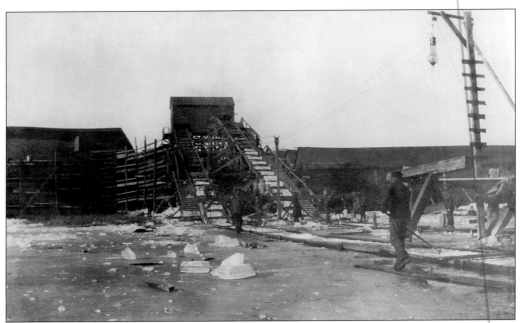

These elevators sat on the lake's northern edge in Armour Town in 1910. Ice blocks rode up the elevator and into the barn, where a man with an ice hook pushed the blocks into orderly rows. When the floor was covered with ice, the ice was covered with sawdust, marsh grass, or cattails and another layer of ice was placed on top. This process was repeated until the barns were full. (LRCM.)

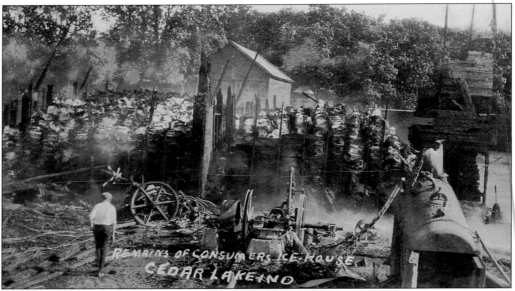

Ice was stored until needed and then shipped by train to Chicago. Winter harvest season lasted about six weeks, depending on weather, and the ice was used throughout the following summer. The 1936 season produced 275 train carloads, or 7,000 tons, of ice. John G. Shedd had interests in several Cedar Lake ice companies. This is Shedd's Consumer's Ice House in Armour Town after a fire. (LRCM.)

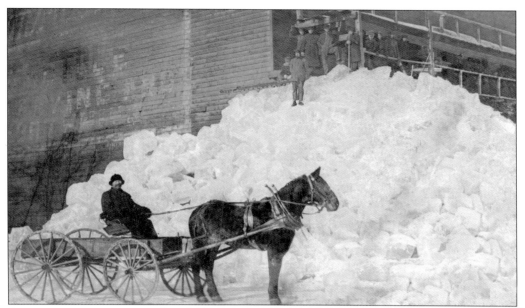

Armour ice companies employed 150 seasonal workers from the 1880s to 1930s. In 1913, an 11-hour shift paid $1.75. Customer orders specified size and quality, and irregularly shaped ice would not stack well in the barn, so the unfit ice was thrown onto a pile similar to this one next to an Armour ice barn. Employees were allowed to take scrap blocks for personal use. (RH.)

Small icehouses sold ice to housewives with wooden iceboxes. A 1920s iceman would call out "ice man" as he entered a kitchen with a dripping 100-pound block of ice on his shoulder. He wore a leather vest as minimal shoulder protection and used a large set of ice tongs. Children would follow the iceman, hoping for an ice sliver to suck on. (LRCM.)

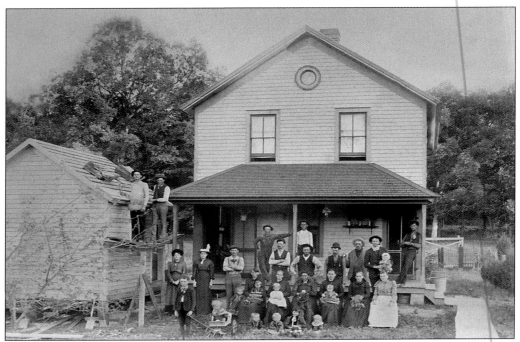

Timothy H. Ball sold the land that became Armour Town. This Peter Horner Sr. home was one of the first built in Armour Town. Home construction in 1890 was a neighborhood affair. Women provided dinner and supervised children while men worked. Women wore long, mostly dark dresses, and some wore hats, even for work. Son Peter Horner married Bea Ewer. Bea was a Cedar Lake historian for many years. (LRCM.)

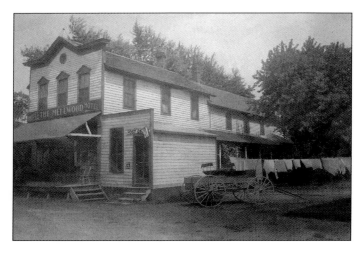

The Mellwood Hotel, built in 1890 in Armour Town, was the town's third hotel. It was an elaborate two-story structure with a good reputation that did good business. The lean-to served as the Armour Town post office from 1914 to 1920. In 1924, a new owner was disappointed with the business; it burned down shortly thereafter. Later, it was revealed that he had spread gasoline and started the fire. (LRCM.)

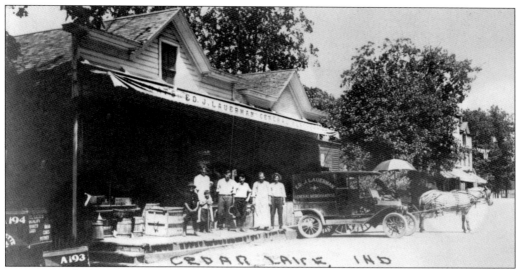

In 1896, Nicholas Mager built a store in Armour Town. Mager sold the store to Matthias M. Lauerman, who moved it and attached it to his Lauerman General Store. The store included a corner for shoemaker Peter Scholl, who gave grandson William Scholl his first shoemaking lessons. Lauerman's son Edward moved half the store west of the lake, near the Gerbing Saloon, to become the Ed. J. Lauerman General Store. (LRCM.)

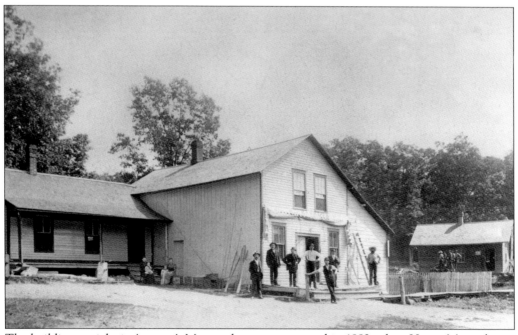

The building at right is Armour's Monon depot, constructed in 1882, when Henry Massoth was the depot agent. Massoth constructed the center building, a combination store, boardinghouse, and saloon with attached living quarters. He ran this business across the tracks from the depot from 1888 to 1899. Store purchases were made via swapping, credit, or—as a last resort—money. This photograph is from 1905. (LRCM.)

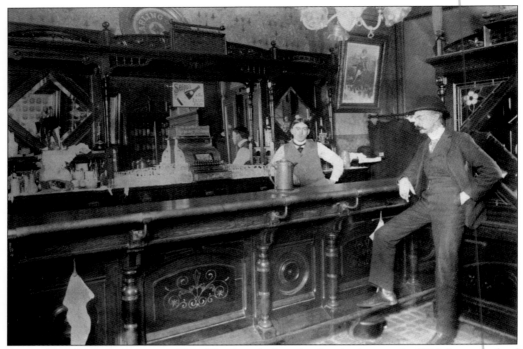

Anton Hein built the two-story Hein Hotel, including this bar, in Armour in 1906. It sat south of the Mellwood Hotel. In 1908, it was sold and Hein built a new hotel in Cook. During Prohibition, the Armour location was called a speakeasy. The family of John and Amelia Hein Jeillson used it as a home until it was torn down in 1940. This photograph is from 1906. (LRCM.)

This c. 1915 photograph shows the Peter Schoenhofen Brewing Company crew at the Edelweiss Depot in Armour. The depot was built in 1894, north of the handle factory. Valentine Ploetz Sr. has a beard (center) and Frank Souhrada is on the right; the rest of the men are unidentified. Large horse-drawn wagons hauled beer daily from the train depot to saloons around Cedar Lake until Prohibition. (SB.)

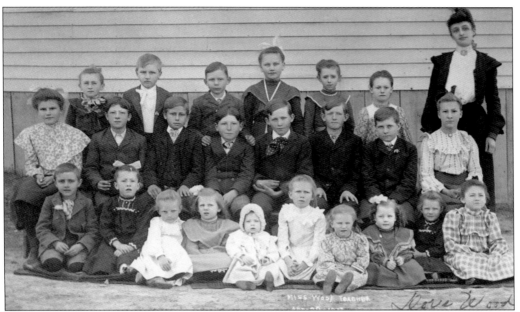

Armour School offered classes from 1885 to 1912. Pictured here are, from left to right, (first row) Edward Austgen, Theresa Hein, Theresa Genzler, Cynthia Mager, N. Mager Jr., Mary Genzler, Barbara Genzler, Ramona Mager, Amelia Hein, and Lena Horner; (second row) Elizabeth Schubert, Danny Hein, Henry Schubert, Geoge Calnon, Louis Herlitz, William Herlitz, Martin Howkinson, and Mary Hein; (third row) Bertha Horner, Walter Schubert, Basil Emmons, Gasche Herlitz, Pauline Austgen, Matilda Genzler, and teacher Doris Wood. This photograph is from 1904. (LRCM.)

Armour ice companies used the train to ship ice, while the Hein and Mellwood Hotels received supplies by train. These businesses needed easier access to the train, and in 1931, this spur was laid from the main line into Armour. Cedar Lake Lumber opened when the train could bring in supplies. Before the spur, coal and lumber were sold door-to-door, like vacuum cleaners. (PCRP.)

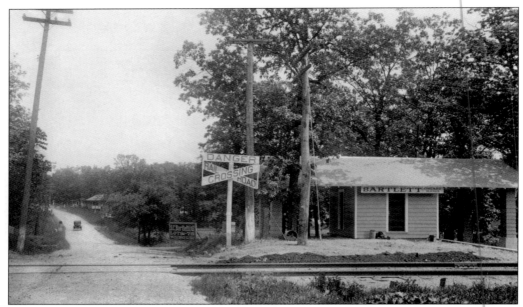

Monon Railroad tracks ran through Armour in 1882. In 1901, the tracks north of Armour sank into the Klondike Sinkhole, and the railroad dumped 2,500 railroad cars of rubbish. The tracks would rise, then sink the next day. This area is the present-day location of Lost Lake. The tracks were moved, and Samuel C. Bartlett convinced the Monon to build a new depot named Bartlett in 1924. (LRCM.)

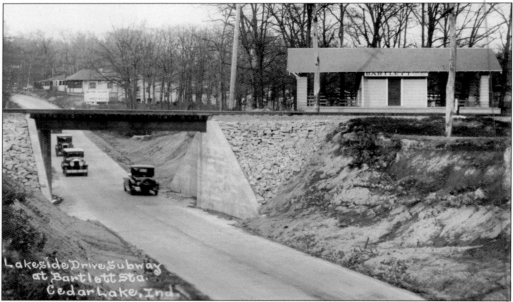

The Bartlett depot sign says "Chicago 38.4 miles." This crossing was very dangerous, and several pedestrians and people in vehicles were killed. In 1928, this underpass replaced the road-level crossing and the stone road was replaced with concrete. Better roads hurt the railroad, as more people drove cars to the lake. In the 1930s, this depot on 133rd Avenue burned down. The concrete abutments remain alongside the road to this day. (LRCM.)

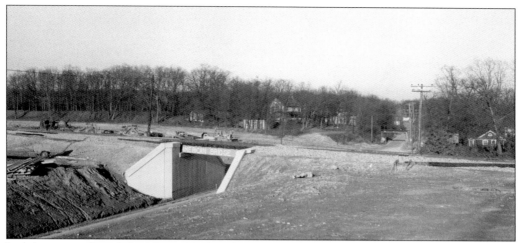

Liability issues forced the Monon Railroad to move the tracks again in 1948. This photograph, taken on November 7, 1948, shows construction of the new underpass on 133rd Avenue. The 1928 underpass stands in the distance. The Armour memorial rock sits on the hill just right of the new underpass, which is still in use today. A 1948 depot was built, but passenger service ended in 1959. Freight service continues today. (JFH.)

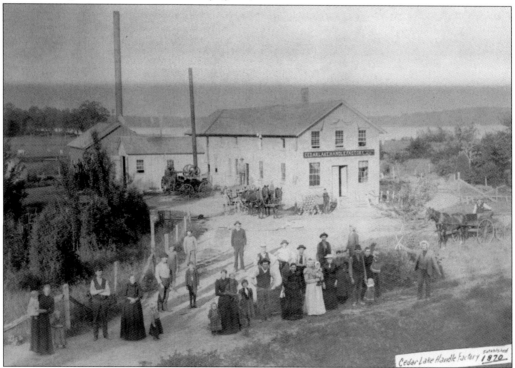

Nicholas Geisen worked with wood in his Hanover Center barn, then built this Cedar Lake Handle Factory in Armour in 1870. Early power came from a large waterwheel. Peter Horner Sr. was a buyer who travelled to Arkansas for hickory logs that would produce strong wooden tools. Local cedar was also used. Iron tools largely replaced wooden tools, and the factory was dismantled in 1926. (LRCM.)

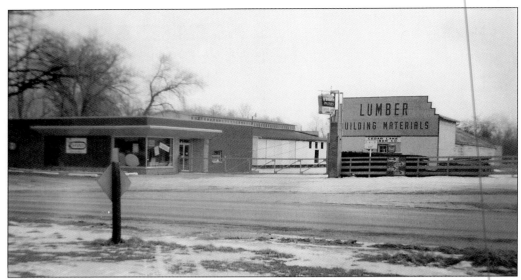

The GeScheidler Bell Factory, located north of the handle factory, produced silver bells from the 1870s until it burned down in the early 1900s. In 1931, Nicholas Mager established the Cedar Lake Lumber Co. at that location. Much of this lumber was used in building the Utopia Subdivision and Lincoln Plaza. The company buildings still stand. Mager's development also required concrete and Mager started Cedar Lake Transit Mix across the street. (LRCM.)

The first Armour depot and Massoth store sat on this site in the 1880s. Then came John Bixenman's Boarding House and Saloon, Lauerman's first grocery store, Genzler's Boarding House and Dance Hall, and a block cement factory. Martin Mager established Cedar Lake Transit Mix in 1950, and it was managed by Raymond Mager. This photograph was taken in 1970. Smith Ready Mix has operated on the site since 1996. (LRCM.)

William and Francis Govert married at St. Martin's Catholic Church in 1910, had this photograph taken at Vilmer Photography, and later celebrated at Genzler's Dance Hall. John Genzler supported his family of 10 children with this establishment. It started as a wood floor under the stars but was eventually enclosed and furnished with plank benches and a potbelly stove. It was popular for wedding celebrations and Saturday night dates. (LRCM.)

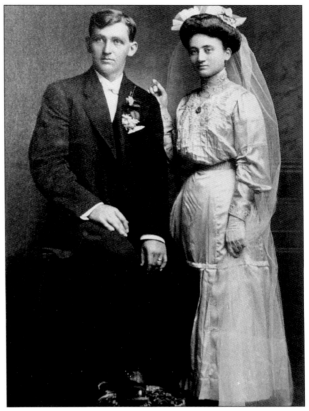

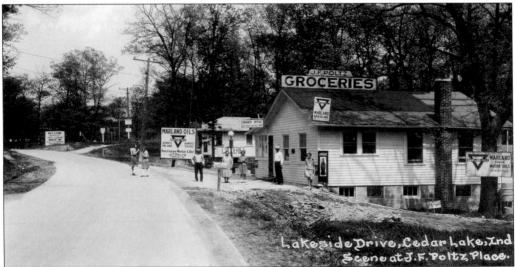

In 1923, Samuel C. Bartlett bought farmland from the Meyer family and developed Meyer Manor and Meyer Terrace. John and Elizabeth Poltz opened this store at the Meyer Manor entrance on Lakeside Drive (also called Lakeshore Drive). This photograph is from 1930. Daughter Mabel Poltz with husband William Cordrey took over and the store became Bill's Grocery. Today, it is Hunley's Restaurant and Bar at 13115 East Lakeshore Drive. (LRCM.)

The American Legion Post 261, chartered in 1946, displays two Nike antiaircraft missiles at their 13050 Washington Street location. Membership is based on military service. Members support local organizations. The Amvets Post 15, chartered in the 1950s, is located at 13335 Morse Street. Membership is also based on military service. Amvets support the Boys and Girls Club and are veterans helping veterans. The Cedar Lake Chamber of Commerce organized in 1971 to join businesses, residents, and organizations to improve Cedar Lake. The chamber welcome center is at 7925 Lakeshore Drive. The Fraternal Order of Eagles Aerie 2529 began in 1954 at 13140 Lakeshore Drive. They are people helping people and give aid to many local organizations. Anyone can apply for membership. The Knights of Columbus Marian Council 3840, founded in 1954 as the strong right arm of the church, is located at 13039 Wicker Avenue. Members are Catholic men 18 years of age or older. The Lions Club District 25A has provided services for the blind for 60 years and currently meets in the American Legion Hall. Membership is open to all. That totals 345 years of community service!

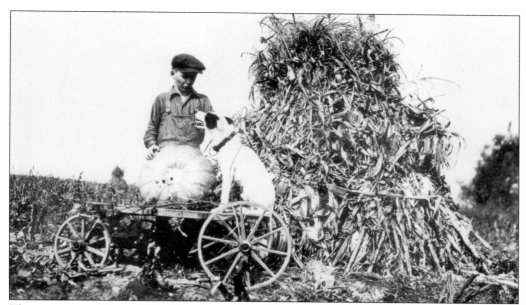

The acreage northwest of the lake changed hands several times before John H. Meyer bought it in 1852. The family raised cows and pigs and farmed there for generations. This photograph was taken in 1923 when Otto Meyer owned the cornfield. It appeared in the *Chicago Sunday Tribune* on April 8, 1923. It was titled "When the frost is on the pumpkin," but it is not recorded how the photograph was used. (LRCM.)

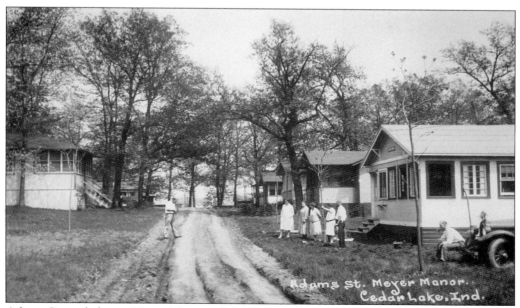

Adams Street led into Meyer Manor, where roads were named after Chicago streets. Truman Circle and Washington Street, now West 132nd Court, was originally a ceremonial path around a mound of earth used as an Indian burial ground. Pioneers were also buried there. The grave marker of Revolutionary War soldier Gordon Van Gorder is dated "1758–1840." The 70-by-76-foot area is now fenced in and surrounded by houses. (LRCM.)

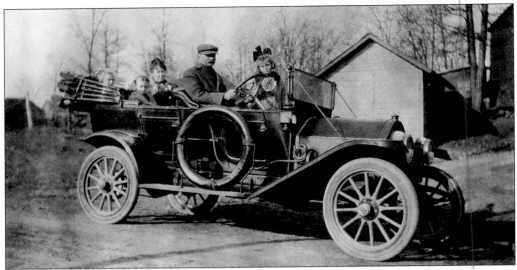

J. Howard Meyer II poses with his wife, Oda, and daughters Florence, Ruth, and Blanche. J. Howard managed the Edelweiss Beer Depot. Matt Lauerman drove the Edelweiss wagon, delivering bottles and barrels to local saloons. William Govert drove Seipp's wagon from the west side depot. Tosetti's Beer Depot was also on the west side, near Biesecker Row. Deliveries were made daily, and beer was kept cold with blocks of ice. (LRCM.)

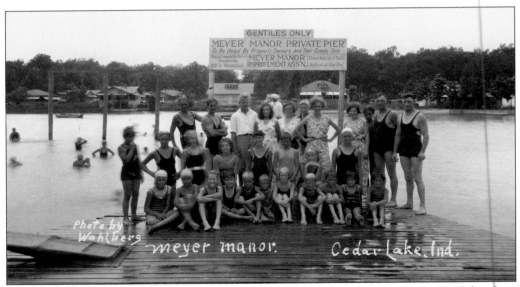

Samuel C. Bartlett bought the Meyer farmland in 1923 and cut the property into 25-foot lots. Summer cottages had no electricity, running water, or telephones. Kitchens had oak iceboxes. Mail was collected from two tiers of mailboxes along Lakeshore Drive. The small cottages were similar to campsites, and days were spent outside. The private pier was strictly for resident use. This photograph is dated 1929. (LRCM.)

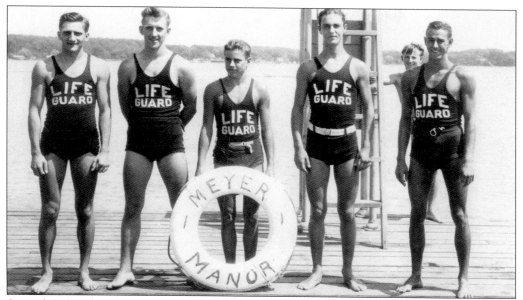

Samuel C. Bartlett, his wife, and his daughter Harriet lived in Meyer Manor. Their house still stands. Bartlett's rules for Meyer Manor required cottages cost a minimum of $600, have two coats of paint within 30 days of construction, have sanitary indoor toilets, and have a five-foot perimeter between the house and the road. Tents were not allowed to serve as permanent dwellings. These young men were lifeguards at the Meyer Manor beach. (ADS.)

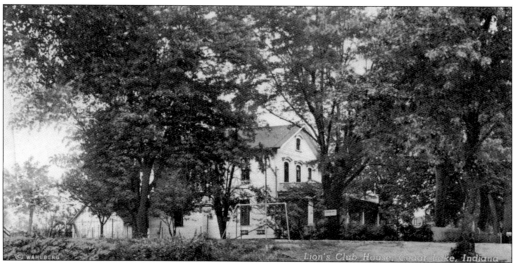

Otto Meyer built a farmhouse on a northern bluff. This undated photograph shows the house after it became the Lions Club clubhouse. In 1954, Jude Eller remodeled the building into a funeral home. Eller's sister Mabel Eller Brady owned it until 1980, when Frederick Oparka bought it and kept the name Eller-Brady Funeral Home. Oparka and his wife, Gloria, raised four children upstairs. Before ambulance service, Eller-Brady transported people in its hearse. (LRCM.)

Lewis E. Herlitz (1804–1869) and his wife, Gasche Herlitz (1810–1875), bought an 80-acre claim on Cedar Lake's northern bluff in 1839. They built a log cabin, raised six children, and, in 1855, built a fine frame home. Son Louis W. Herlitz (1841–1916) married Anna Meyer, served in the Civil War, and had a son also named Louis. Farming was a hard life, but the Herlitz family worked together with neighboring farmers in the Meyer, VanHollen, and Ball families. (MAK.)

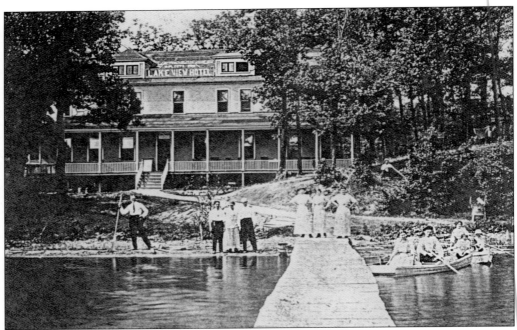

Valentine and Marie Ploetz built the Lakeview Hotel in 1910. During the winter of 1912, an employee fell through the lake ice and Valentine tried to help. Valentine Jr. saved the employee, but the father drowned. Marie managed the hotel until it burned down in 1920. This is the current site of Water's Edge Condominiums, built in the 1980s at 8125 Lakeshore Drive. Marie ran Lakeview Park, across from Blizzard's Grocery, until the 1930s. (LRCM.)

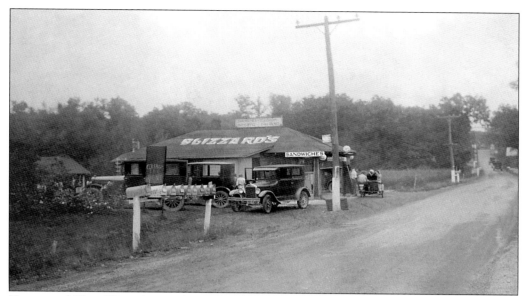

Horace and Clara Blizzard opened a tent market at Foster Street and Lakeshore Drive in 1921. The market became this building, and gas pumps were added. Mailboxes were for residents of Blizzard Subdivision, which began behind the store in 1918. Going east was Pete's Tavern, where the Fox Deluxe sign still stands. Next was Joe and Charley's Meat Market, known for its homemade Polish sausages. It was later called Friendly Inn Tavern. (LRCM.)

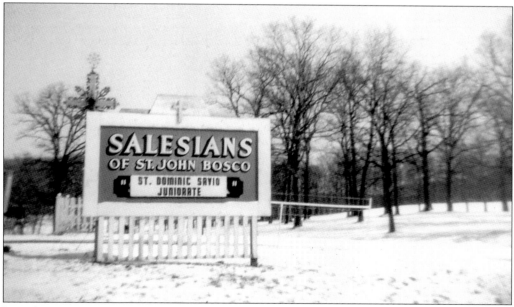

In 1956, property was purchased by Salesians of St. John Bosco, a Lithuanian Catholic religious society, to be used as a seminary. Extensive facilities were built, but financial difficulties caused its closing in 1979. New owners tried to establish a health facility and a nursing home, but neither worked out. It was last used in 2001 as a haunted house. Havenwood Subdivision was developed across the street in 1992. (KB.)

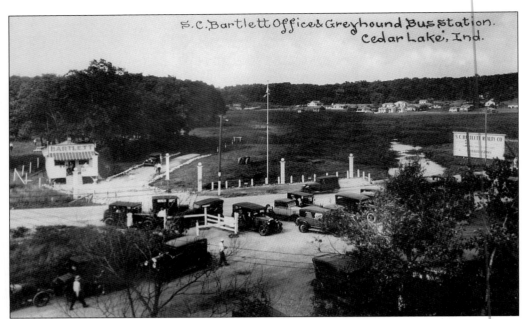

Samuel C. Bartlett opened this sales office in 1913. Horace Blizzard met buyers at the train station and bused them here. A miniature golf course occupied waiting prospective buyers. In 1947, Allen Aanerud bought the property, expanded the office into a home for his use, and ran a picnic grove and trailer court. Daughter Anne Aanerud Zimmerman lived in a back house, and the billboard, on the right, was dismantled to become part of Zimmerman's kitchen floor. (LRCM.)

OUR PLAN

WE ARE SELLING LOTS — 25 x 100 feet — in this beautiful subdivision for $40.00 — $10.00 at the time of purchase and balance payable $10.00 monthly until paid.

NO INTEREST — NO SPECIAL ASSESSMENTS — NO EXTRAS OF ANY KIND

Remember — Each lot faces on a street made by us without expense to you

Samuel C. Bartlett's main office was at 36 South State Street in Chicago. His advertisements in Chicago and Gary newspapers told of two fine golf courses, a theater, and Indiana's most beautiful lake. He called Cedar Lake the "Coney Island of Indiana." Another advertisement tells of heavily wooded lake lots for $125, with $1 weekly payments. Gus Wahlberg made a 1929 promotional video for Bartlett, and the lots sold. (LRCM.)

Allen Aanerud sold real estate for Samuel C. Bartlett, but Bartlett did not sell cottages. Wilbur Lumber and Henderlong Lumber supplied building materials, and local carpenters built the cottages. This log cabin style was built in the Trend Subdivision around 1916. A.L. Halley Realty and Burke's Realty also had offices here. No one matched Bartlett, who bought land anywhere he could and developed a total of 30 subdivisions. (LRCM.)

Bartlett subdivisions included areas designated for stores and private beaches. He did not allow outhouses. Many cottagers used their large front porch for fresh air sleeping quarters. Bartlett was an entrepreneur, and he created good vacation destinations. But the Depression began in 1929, and World War II began in 1939, lasting until 1945. In those years, many people lost their primary homes and the tiny cottages became permanent residences. (LRCM.)

Nicholas Mager built Dick Smith's North Shore Inn along Lakeshore Drive c. 1920s; however, the business failed. A drugstore was built on the grassy triangle to the front. Jackson's Drugs opened in the East Side Shopping Center, then moved here. It was also Lyle's, John's, Pugh's Drugs, and Fagan Pharmacy. The drugstore was demolished in 2001, and the grassy triangle is now part of the Cedar Lake Chamber of Commerce parking lot. (ADS.)

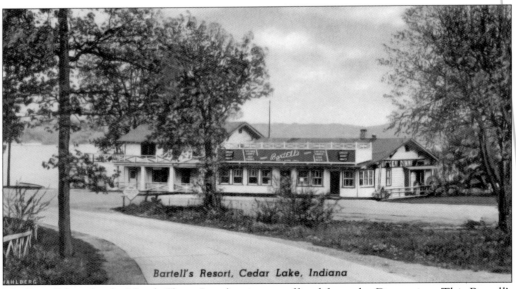

Bartell's Resort, Cedar Lake, Indiana

Mr. Bartell bought the North Shore Inn, but it too suffered from the Depression. This Bartell's Resort postcard is dated 1948. The building became the Surf Side 6 Teen Club in the 1950s and burned down in the 1960s. In the late 1980s, the chamber of commerce acquired the land. A neglected lakeshore became a small park, boat launch, and a welcome center with parking for cars and boat trailers. (LRCM.)

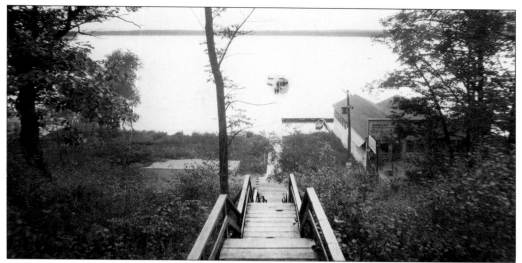

This steep stairway runs from Samuel C. Bartlett's subdivision down to the subdivision's private beach. Today, this is called Bartlett Park, and it is open to the public. The building to the right was Zeiger's Store in the early 1920s. Much of the shoreline in this area has been filled in, extending owner's property into the lake. This was a common practice around the lake but is no longer allowed. (LRCM.)

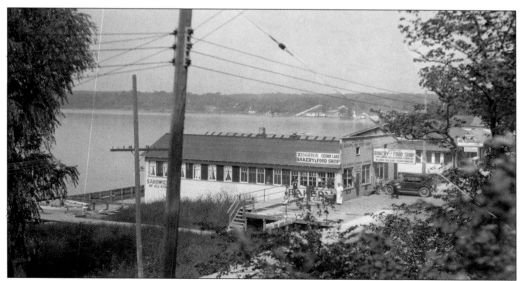

In 1929, Zeiger used a pick and shovel to dig a basement below the existing structure. Homemade baked goods were a specialty, and mail could be collected in Zeiger's Bakery and Food Shop. Bull Durham and Cracker Jack were brands of the day. Later, it was Kohler's Bakery. The building sits north of Bartlett Park and is currently a warehouse. The Victor's Beach slide can be seen across the lake. (LRCM.)

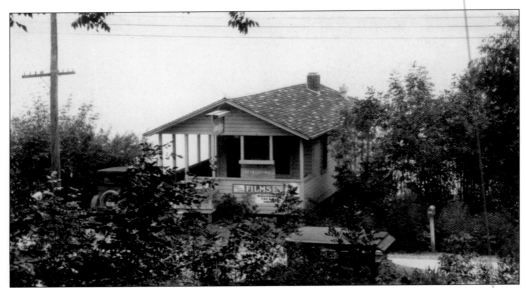

Gus Wahlberg opened his 1926 camera shop in this building, where he sold and developed film and learned photography. Employee Florence Weiert fell in love with photography and then with Gus. They married in 1937 and raised four children. Gus died in 1967, and son Ted Wahlberg continued the business. The building has expanded into a full-service studio and grandson Ryan Henderlong continues as Wahlberg Panoramic Photography. (RH.)

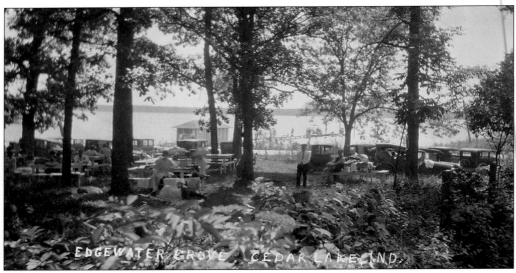

The Edgewater Beach Hotel and tavern was built by Adolph Von Borstel Sr. Son Adolph Von Borstel Jr. continued the business, which flourished when the roadway opened between Armour Town and Crown Point in 1906. The pier had a row of small changing rooms for swimmers and a vending stand selling pop and beer. Picnics were held in the grove. The hotel burned down and the Town Club currently occupies the site. (LRCM.)

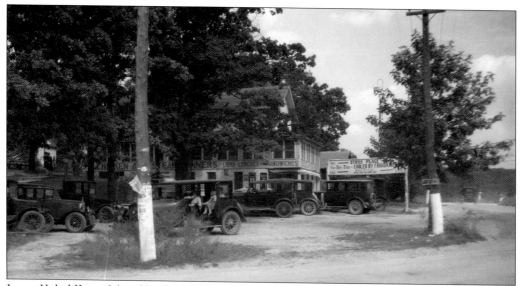

James Kubal II met Mary Hetzler at Lassen's Ballroom. They married and son James Gerald Kubal III (Jimmy) was born in 1916. James II died in the 1918 flu epidemic, and Mary supported herself working in her mother's store. In 1924, Mary wed Jack Stife, and the store became Stife's Place. Jimmy graduated from Butler University in 1939 with a teaching degree, but Mary was sick and Jimmy had obligations. (LRCM.)

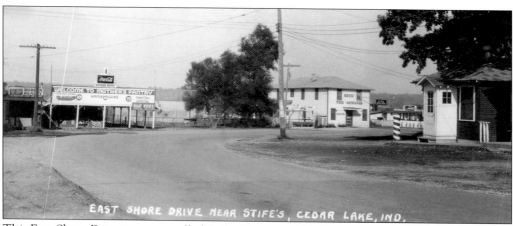

This East Shore Drive turn was called Stife's Corner. Stife's Place was to the right, outside of the picture. Jimmy Kubal helped his mother run the store as an IGA and introduced self-service. The small building to the right was Woody's barbershop. To the left was Burke's Realty and Mother's Pantry. Mother's has been a bait shop and several restaurants, most recently Boondock's. Next came the Bon Ton Club, formerly Hetzler's icehouse, and Midway Snack Shop. (ADS.)

Jimmy Kubal served in the Navy Air Corps, married Martha (Martie) Nice, and returned to Cedar Lake. He bought his mother's store and began developing the East Side Shopping Center. The first Cedar Lake Roller Rink was at the present-day site of Hanover High School. This second rink, at Stife's Corner, provided entertainment until 1969. Bob Carnahan worked there and has good memories of this rink. This photograph is from around 1967. (GJ.)

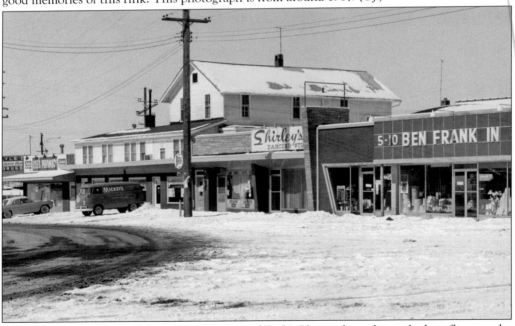

The East Side Shopping Center was built around Stife's Place, where the peaked roofline can be seen today. The Ben Franklin Dime Store is now Zip Foods. Tenants changed, including Shirley's Dance Studio, Aunt Fanny's Coffee Shop, and Mickey's Laundry. Some residents have held boxes at the contract post office for more than 60 years. In 2011, the Dollar Store and Gleaners occupy the northern strip and Lyle's Pharmacy is empty. (RH.)

James Dennis (Denny) Kubal, son of Jimmy and Martie Kubal, rides the kiddie car attraction on the east side of the lake. From the late 1940s to the early 1950s, this small carnival-like area operated south of the present-day Dairy Queen. Many acres in this area belonged to the Hetzler family. When Adam and Theresa Hetzler died, the property was divided among their children. (MK.)

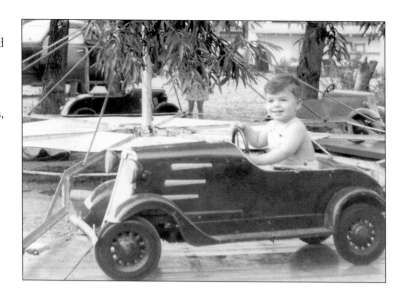

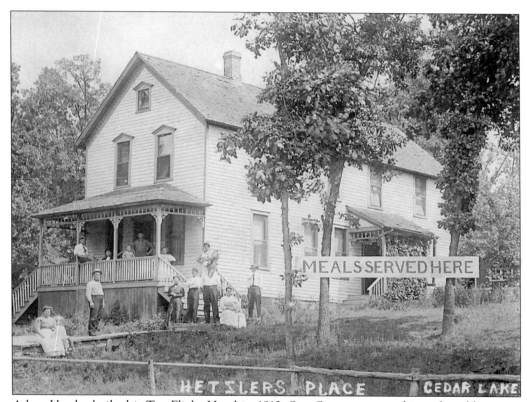

Adam Hetzler built this Top Flight Hotel in 1912. Son George managed it and could not pay the taxes. He sold to his sister Mary Kubal Stife, and she gave it to her son Jimmy Kubal. In the 1950s, Jimmy wanted a liquor license, but state law required a 25-room hotel for this license. Jimmy moved the hotel across the street, attached it to the Midway Ballroom, and received his license. The original Top Flight sat near the current Pier 74 Pizza and Grill. (MK.)

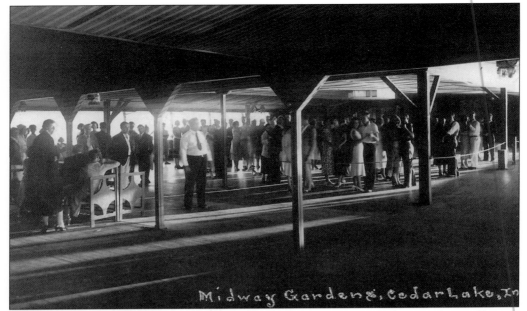

Midway Gardens, Cedar Lake, In

George Hetzler rebounded with the lakefront he inherited. He signed a lease with two Chicago doctors to put a ballroom over the water from his land. The markets crashed in 1929, the doctors walked away, and George owned the ballroom. George is seen here in the white shirt in the open-air ballroom that he developed as Midway Gardens. (MK.)

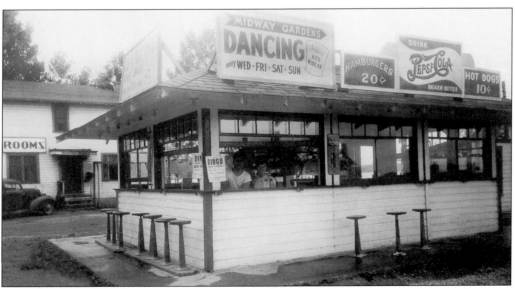

Jimmy and Martie Kubal work the Midway Gardens Snack Shop in this 1940s photograph. Jimmy bought Midway Gardens from his uncle George Hetzler in 1946 and called it Midway Ballroom. The walls were open, there were two long benches along both sides of the room for seating, and 12- and 14-piece bands played there, mostly on Monday nights. Bathroom facilities were in a separate building on the shore. (MK.)

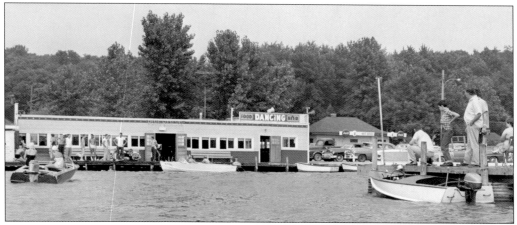

In 1946, returning servicemen could buy a dance at Midway Ballroom for 25¢. Musician union rules controlled the number of miles a band could travel between jobs. Cedar Lake fell in line as a good stopping place for bands after playing in Chicago. Names like Woody Herman, Les Brown, and Stan Kenton played here. Martie Kubal danced with Lawrence Welk. Open windows allowed boaters to listen for free. (MK.)

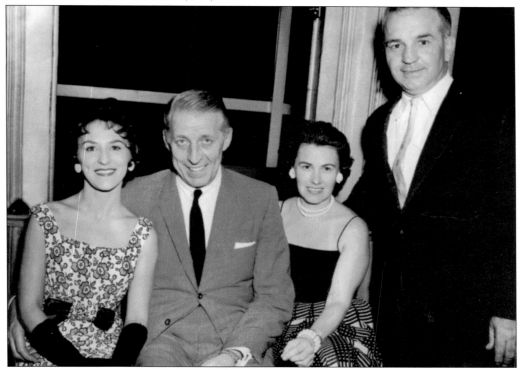

Pictured here are, from left to right, unidentified, Stan Kenton, Martie Kubal, and Jimmy Kubal. The Beach Boys drew possibly the largest crowd to the Midway Ballroom. Over the years, musical tastes changed to include the Everly Brothers, Iron Butterfly, Steppenwolf, Barbara Mandrell, Conway Twitty, and more. Mel Tillis was seen fishing off the pier between sets. The attached Longhorn Restaurant offered a one-and-a-half-pound Porterhouse steak with the trimmings for $6. (MK.)

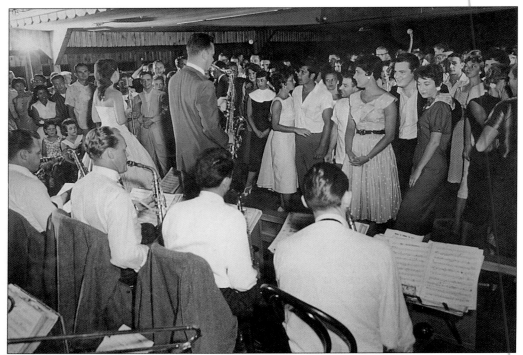

This is the Billy May Orchestra at the Midway Ballroom in 1956, at a time when dancers came in dresses and jackets. Another night, WLS disc jockey Jim Lounsbury led dancers in the bunny hop, making the wooden floor shake! Jimmy Kubal's son Brian Kubal took over the ballroom in 1979. In 1987, it was totally lost to fire. State law will not allow another ballroom to be built over the water. (RF.)

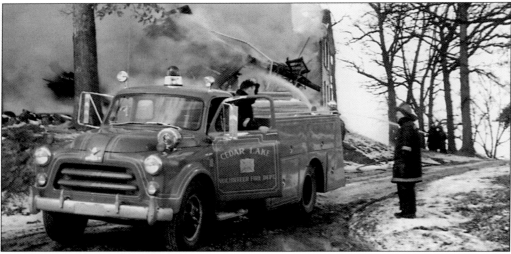

In 1885, Jack Burke built a hotel on the northeast lakeshore, with 20 stairs leading up the hill behind. Mrs. Kennedy inherited the property and built the much larger Kennedy Hotel on the hill. Bullet holes in the outer Kennedy Hotel walls were allegedly from an Al Capone shoot-out. Jimmy Kubal purchased the hotel after World War II. In 1960, he remodeled extensively, but it was lost to this fire in 1968. (GR.)

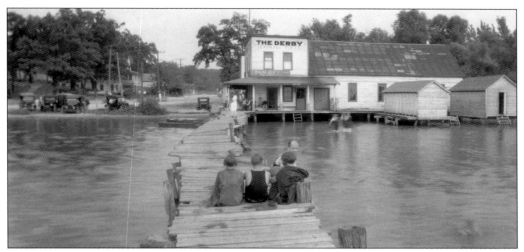

In 1904, William White built a hotel extended over the water called White City on Hetzler Road. In 1928, James Leather bought it and renamed it the Derby Hotel. James Leathers Sr. was shot to death in the Derby Saloon. The old Burke Hotel was to the right. Stife's Place is in the background on left. Much later, the Cedar Lake Roller Rink sat on the Derby Hotel land. (LRCM.)

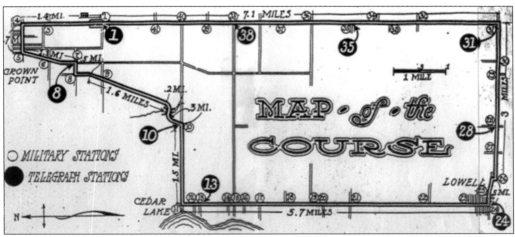

The 395.66 mile Cobe Cup Race ran through Cedar Lake on July 19, 1909. The 23.27-mile course included the dangerous S-curve out of Crown Point. Twelve cars entered, including Buick, Corbin, Marion, Ford, Chalmers Detroit, Locomobile, Moon, Renault, Stoddard-Dayton, and Fiat cars, racing at 40 to 60 miles per hour. Crip Binyon set up a repair shop fixing flat tires and overheated engines. A shorter race took place on July 18. (LRCM.)

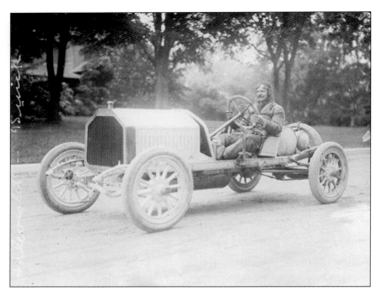

Drivers wore touring coats, cloth helmets, and goggles. Louis Chevrolet of France won with an average speed of 49.26 miles per hour in a 32-horsepower Buick. His winning time was eight hours, one minute, and 39 seconds, with a 65-second lead. Ira Cobe, president of the Chicago Motor Club, presented the trophy. After one year, the race moved to Indianapolis, and two years later, it became the Indianapolis 500. (LRCM.)

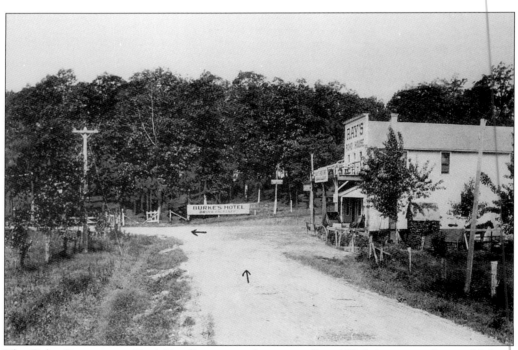

The Cobe Cup ran past Ray's Roadhouse on what is now East 133rd Avenue and turned left on Cobe Cup Road, now Morse Street. "Diamond" Jim Ray built the roadhouse around 1890 and earned his nickname by expertly removing diamond rings from the hands of female patrons. Neighbor Jack Burke and Jim Ray could not visit Chicago because they were on Chicago's wanted list. (LRCM.)

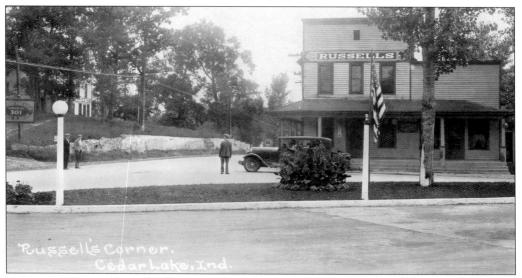

Bob Russell bought Ray's Roadhouse in the 1920s. In this 1932 photograph, the roads have been paved and electric streetlights were installed. The Kennedy Hotel is on the hill to left. Russell's also had a questionable reputation, and men who valued their reputation stayed away. It is said that John Dillinger frequented the bar. During the Depression, Russell's offered free chicken with a beer every Saturday night. (LRCM.)

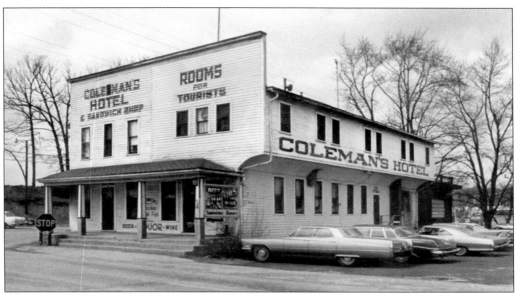

Karl and Della Coleman bought Russell's in 1933. Mary, who answered a help wanted advertisement, waited tables and eight years later married the Coleman's son Roscoe. Roscoe and Mary were famous for fried chicken at Coleman's Corner. Coleman's, pictured here in the 1960s, is the only hotel that survived into the 1980s. In 1989, Al (Juno) Bunge Jr. purchased the hotel, tore it down, and established Lake Shore True Value Hardware, which is still in business today. (LRCM.)

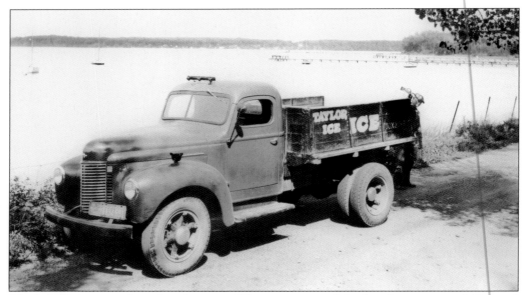

Obadiah Taylor served as a Revolutionary War minuteman, defending Lexington and Concord on April 19, 1775. Great-great-grandson Thomas J. Taylor built a small icehouse in the 1920s. Thomas and son Thomas J. Taylor Jr. delivered ice locally until 1960. This photograph is from 1941. In 1955, Thomas Jr. built a gas station, and in 1967, he built TJT General Tire Service, Inc. Both are located on East 133rd Avenue, and Todd Taylor, Thomas Jr.'s son, still operates the tire business. (TT.)

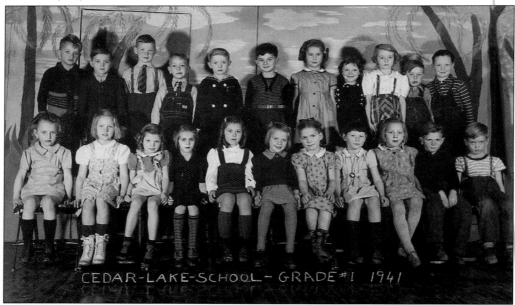

CEDAR-LAKE-SCHOOL - GRADE#1 1941

The Red Cedar School was built on the east side in 1840. The 1865 teacher taught 36 pupils, ages five to 23 years old, and made $14 a month. In 1885, Red Cedar was replaced by the brick Binyon School, heated with wood-fired stoves that still required children to wear coats and boots in class. In 1928, Binyon burned down and was replaced by the Cedar Lake School built on Fairbanks Street. (LRCM.)

The brick Cedar Lake School was built on Kolar farmland. The first grade started in 1930. One of the first graduates in 1937 was Ernest Niemeyer, who went on to become a state senator in 1975. The original structure was replaced in 1962 at 12900 Fairbanks Street and renamed MacArthur School after Gen. Douglas MacArthur. The Cedar Lake Boys and Girls Club opened in 1982 to the south. (BC.)

In 1836, several hardworking Bohemian families settled just east of Cedar Lake, in a swampy area with a dangerous sink hole. This family helped to drain and reclaim that area called Buck Hill or Little Bohemia. The Philip Maracek family came in 1875. In 1972, the Maracek farm was dedicated as Lemon Lake County Park. Robins Nest Subdivision was developed in 1995 across the street inside the town limits. (LRCM.)

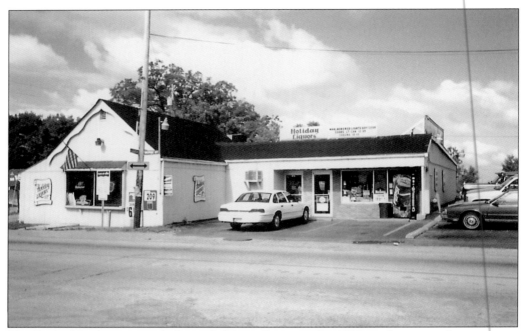

The Burke Hotel was moved alongside Morse Street in the 1930s and continued as a tavern. The next owner, Jimmy Kubal, operated it as the Gaslight Lounge, where millworkers would stop in the mornings for a pint on the way to work. The Kennedy Hotel burned down in 1968, and with it went the liquor license. The tavern became Holiday Liquors Store, and WPM bought the property in the early 2000s. This photograph is dated 2000. (MK.)

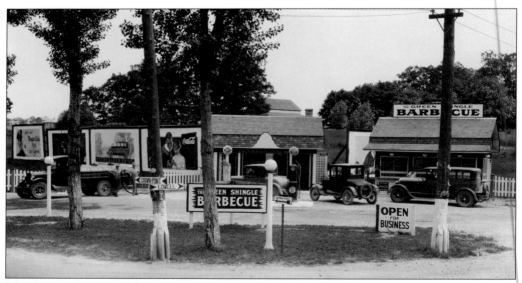

The Green Shingle Barbecue and Monarch Oil Company sat on the southeast corner of East 133rd Avenue and Morse Street in the late 1920s. Billy Rose owned the area, and it was known as Rose's Corner. Later came Mike Peterman's used car lot. In the early 2000s, Holiday Liquors moved from across the street into the current building. The original Gaslight Lounge bar and cash register can be seen there. (LRCM.)

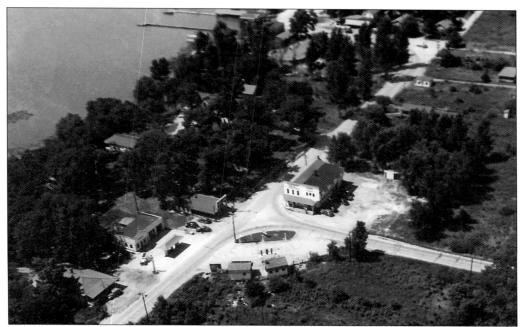

This aerial view of East 133rd Avenue and Morse Street was taken in the early 1930s. Rose's Corner is seen at the bottom of the photograph, in the center. Coleman's Corner is to the north. The Gaslight Lounge is to the left, and to the south is Billy Rose's Standard Oil gas station. Rose also owned Beachcombers, a popular picnic and swim area behind the station toward the lake. The high hill to left is hidden by trees. (MK.)

The hill behind the Gaslight Lounge was removed beginning in 1974. While digging to lay sewer lines in 1977, a wood casket and the remains of Obadiah Taylor, Calvin Lilley, and others were uncovered. In 1920, the cemetery had been declared abandoned. The remains were reburied and given a memorial stone near MacArthur School. In 2007, WPM Construction developed the site with 60 units in the Sunset Harbor condominium complex. (CO.)

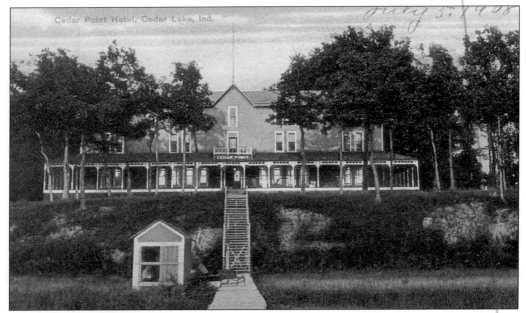

Sigler and Thistlewaite Builders erected the Cedar Point Hotel in 1893, and it was later called the Thistlewaite. This modern hotel had 100 rooms in three stories, serviced by maids, busboys, cooks, gardeners, and stablemen. Many guests arrived by train, and guests with reservations received a free boat ride across the lake to the hotel. The Thistlewaite burned down in 1914. During the next several years, the area reverted to wilderness. (ADS.)

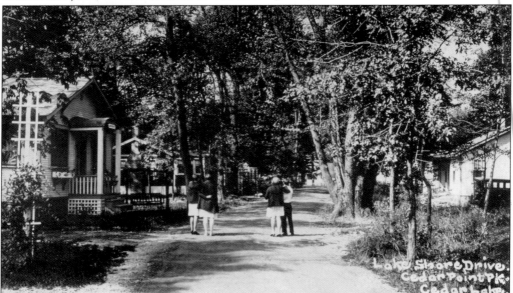

In 1920, the overgrowth was cleared away and Adam Schafer hauled five acres of land from Knesek farmland to Cedar Point to fill in the swampy shoreline. The 30-acre subdivision was laid out with 475 lots, selling for $175 each. Residents had pier privileges, parking, and picnic areas along 2,000 feet of lake frontage. This area also suffered during the Depression, stretching the capacity of tiny septic systems. (LRCM.)

92

The 1950s Royal Blue Grocery Store was built by George and Cordula Schutz. The building has been Lakefront Maintenance at 13640 Morse Street since 2005. Across the street is Cedar Lake United Methodist Church, which started with a Sunday school that met in the Cedar Lake School in 1933. Ground breaking for the church basement was in 1946, and the upper portion was started in 1954. Chris Lance was the pastor in 2011. (BC.)

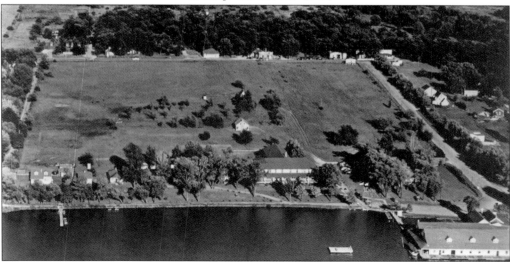

This is Lassen's 20-acre property. The dance pavilion sits to the right, and the hotel sits in the center. The rear hotel wing was originally the Armour Hotel, built in 1895. Christopher Lassen bought the hotel and loaded it onto wooden skids; Nicholas Mager supervised as a Pierce Arrow truck pulled the hotel across thick lake ice in the winter of 1919. Armour Ice House lumber was salvaged to build the north-south wing. (ADS.)

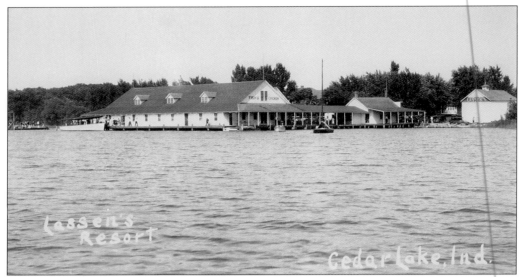

Christopher and Harry Lassen built the Lassen Bros. Dance Pavilion in 1904. Ten years later, an indoor dining room was added, where the specialty was fried chicken. Lighter food service was offered on the outside porch. The small building on far right was the Lassen icehouse. Ice was farmed from the lake and stored here, and the ice was not sold. It was only for Lassen's use. (LRCM.)

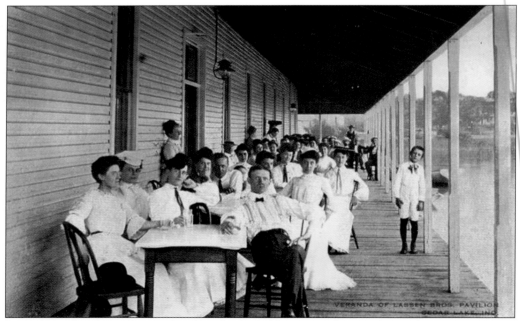

Lassen's pavilion was advertised as 50 miles from Chicago, with an orchestra during summer. At one time, the Lassen complex was compared to the Grand Hotel on Mackinac Island. Elegant city visitors flocked to the lake. This photograph may be of an afternoon lunch on the veranda. A November 14, 1940, windstorm did much damage to the dance pavilion and hotel. It was called the worst windstorm in 40 years. (GJ.)

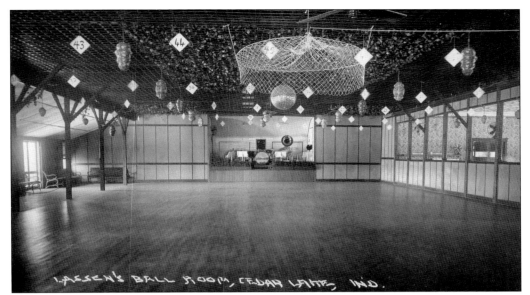

In 1928, admission was 50¢ to dance all night to songs like "Am I Blue?" and "Tip Toe Through the Tulips." The small stage featured big names like Benny Goodman and his orchestra. Craig Parker remembers his father talking about Frank Sinatra and the Tommy Dorsey Band at Lassen's. Women wore long bouffant dresses, and young swains wore stiff straw hats, known as cadies. Hired bouncers kept the peace. (ADS.)

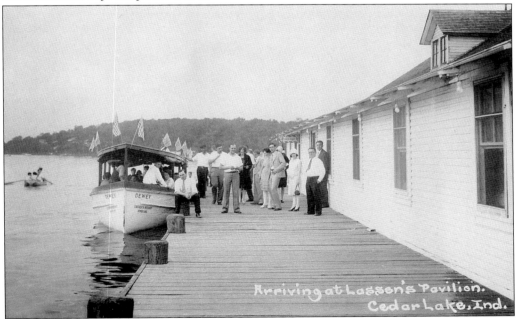

In early 1900s, Christopher Lassen bought one steamboat to give rides around the lake. He kept buying until eight boats made up the Dewey Line. Among them were the *Little Dewey*, *Dewey Flyer*, *Big Dewey*, and *Dewey Dandy*. Competition with other hotels was fierce. Lassen boat drivers walked the Monon pier with a megaphone, calling "Take the Dewey Line." In the 1920s, steam engines were replaced with gasoline engines. (LRCM.)

95

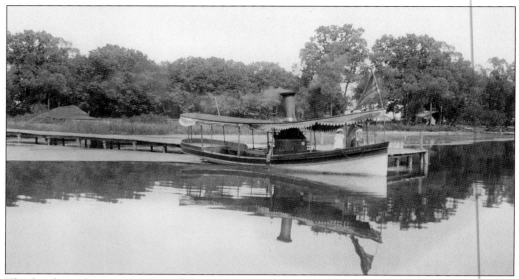

The first boats here were Indian dugout canoes. In 1859, Adelbert D. Palmer contracted Obadiah Taylor to build a two-masted 100-passenger schooner called *Young America*. Excursion boats traveled pier-to-pier, bringing tourists from the train depot to vacation destinations. Locals used these boats like a bus to visit friends or cross the lake for groceries or mail. This is the steamboat called *Dispatch* owned by Joe Hoffman. (FH.)

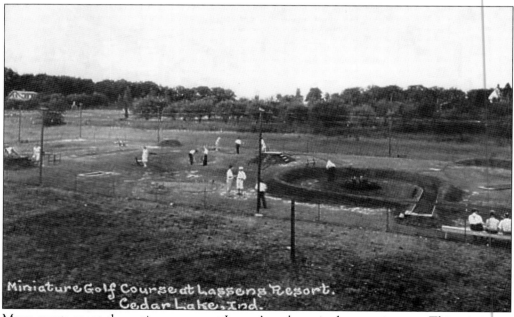

Miniature Golf Course at Lassens Resort. Cedar Lake, Ind.

Many guests spent the entire summer at Lassen's and required entertainment. This miniature golf course was built mid-way to the main road in 1930. It was called the Pee Wee Course and was managed by Ambrose Rascher, who worked to earn money for college. Rascher went on to become a Big Ten wrestling champion from 1931 to 1932 and an Olympic wrestling finalist in 1932. He played professional football for the Spartans of Portsmouth, Ohio. (GJ.)

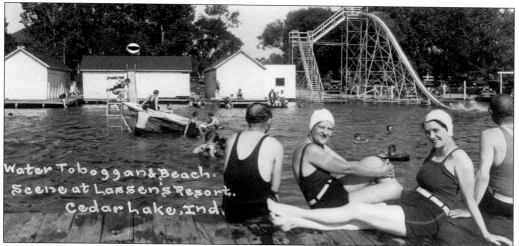

The lake was the major attraction for city dwellers that came to escape the heat. Lassen's offered 700 feet of shoreline, and matched the competition with a tall water slide. The three white buildings are on piers over the water and contain small changing rooms and a concession stand. At the time, women always wore a rubber bathing cap, which made hair look worse than if it were wet. (ADS.)

These three women are taking a break from their jobs at Lassen's in this photograph dated 1933. They were the entire maid staff for the hotel during the summer season. The maids are, from left to right, unidentified, Charlotte Whitmore (niece of Hazel), and Hazel Lassen (Christopher's wife). Other male employees were musicians or drivers for the Dewey Line of boats. (LRCM.)

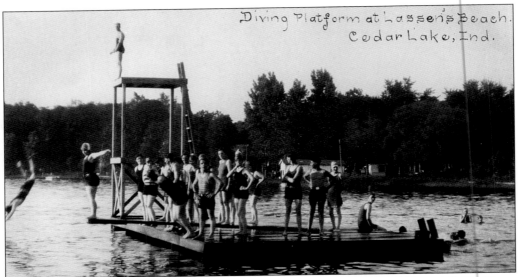

The Lassen diving platform offered another popular lake activity in the 1920s and 1930s. Harry Lassen died in 1936, and Christopher Lassen continued the complex until he sold it in 1947. The property was valued at $200,000, but he sold it to the Lake Region Christian Assembly (LRCA) for $55,000. Lassen also served as the Democratic state representative in the 1930s. (LRCM.)

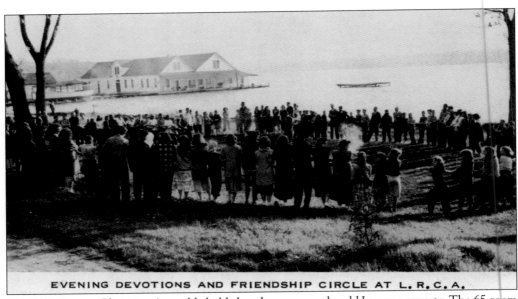

The Lake Region Christian Assembly held church camps on the old Lassen property. The 65-room hotel became the Hotel Christian. The hotel did not, and still does not have heat, so it was only used for the summer season. The storm-damaged dance pavilion was razed. By the mid-1970s, the LRCA was looking for a larger location, and in 1977, the property was sold to the town of Cedar Lake. (LRCM.)

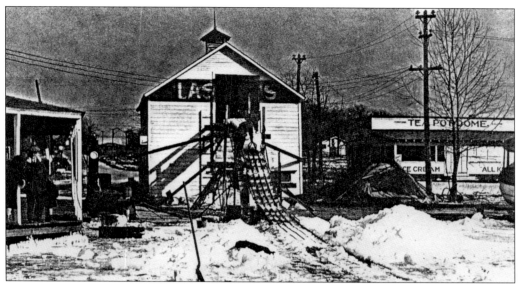

Ice was farmed from the lake and sent up the elevator into the icehouse built in 1904. Ice was insulated with straw and supplied cooling for food storage and drinks during the following summer. To the rear is the Tea Pot Dome Restaurant, built by Dave Spindler in 1920. Christopher Lassen did not allow gambling, so patrons were sent to the Tea Pot Dome to place bets. (LRCM.)

Dave Spindler sold the Tea Pot Dome Restaurant to brother Tobe Spindler, who enlarged the building and called it Tobe's Restaurant and Lounge. Tobe and his wife, Helen Edgerton, ran the restaurant until Tobe died, and it was sold to daughter Norma Spindler and her husband, Fred Holloway. The Holloways ran the restaurant for 38 years, where people would wait an hour or more for the biggest, best steak sandwich or pork chop in the area. (BC.)

The icehouse was torn down many years ago and aging Tobe's Restaurant was razed in the early 2000s. Whiteco Industries, Inc., bought the property and built this Lighthouse Restaurant almost on the site of the icehouse. It opened in April 2009 and has already been enlarged two times. A gazebo and a beach are being added in 2011. The restaurant offers a return to the feel of a resort community. (BR.)

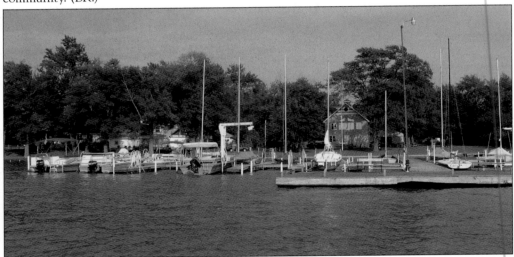

The Cedar Lake Yacht Club began in 1932. Meetings were held at the Surprise Country Club. William P. Dudley was the founder and first commodore. The list of governors included Glen Surprise, Christopher Lassen, Monte Biesecker, Samuel Bartlett, and others. In 1959, the yacht club purchased the northwest corner of the LRCA property, including the former summer home of Christopher Lassen. This is the yacht club in 2006. (CO.)

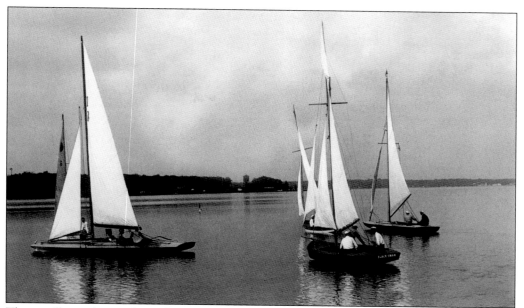

These sailboats date to the early 1900s. Yacht club members continue to hold sailboat races every Sunday morning from May to September. The South Lake Sailing School offers summer classes. The Lassen home was extensively renovated and made fit for year-round use. In 1976, additional land was purchased from LRCA, giving the club a total of 175 feet of lake frontage. (LRCM.)

The town purchased 650 feet of lakefront LRCA property, which extended to Morse Street. The Hotel Christian, formerly the Lassen Hotel, would have been razed if it were not for the Cedar Lake Historical Association, which organized in July 1977. The hotel became this Lake of the Red Cedars Museum. It was placed in the Indiana State Register of Historic Sites in 1980 and in the National Register of Historic Places in 1981. This photograph was taken in 2006. (CO.)

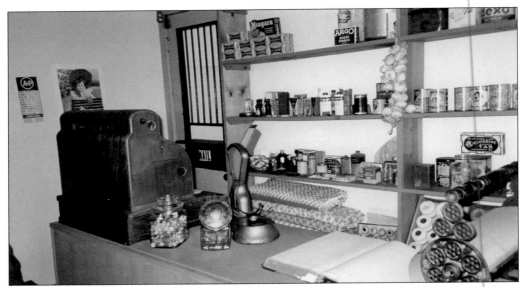

The historical association has a 50-year museum lease with the town. Many rooms have been renovated, like the pictured general store. Peter Scholl's shoe repair tools, the mastodon bone, arrowheads, Dr. Robert King's office, and more can be seen. Lake of the Red Cedars Museum tour hours are Thursday through Sunday, from 1:00 p.m. to 4:00 p.m. during the summer. The wood floors creak and sometimes the roof leaks, and some say there are ghosts here. (LRCM.)

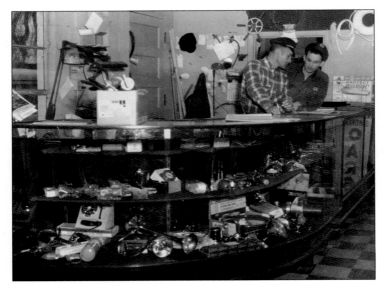

In 1925, Christopher Lassen opened a boat repair business on the shoreline. Bill Lawson owned the business when it burned down, along with about 30 pleasure boats and the lake patrol boat, in 1957. Firemen cut through seven inches of ice to draw water from the lake. Lawson rebuilt and sold it to the Gornick brothers, pictured in the salesroom, in 1959. Gornick Bros. Marina operated from 1959 to 1995. (DK.)

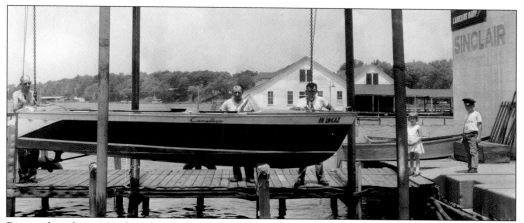

Pictured in this 1962 photograph are, from left to right, unidentified, Erwin Zimmerman, Harold Zimmerman, Chris Zimmerman, and Paul Zimmerman. They are putting Erwin's new boat in the water at Gornick Bros. Marina. The Gornick brothers were known worldwide for boat restoration. Boats were shipped to them from as far away as England. Mike McCormick bought the marina in 1996, Don King bought it in 2004, and WPM bought it shortly thereafter. The buildings have been removed. (DK.)

The Cedar Lake Police Department began in 1966. Two police cars were purchased, and businesses and residents donated supplies for an office. When incorporation was overthrown, the cars and supplies were put into storage. When incorporation became official in 1969, the police department was located at 13300 Morse Street, the present-day site of Amvets Post 15. The 1966 marshals pictured here are, from left to right, Bill Whisler, William Shanks, John Mitchell, and Thomas Anderson. (PCRP.)

The Cedar Lake Metropolitan Police Department replaced town marshals in 1971. Edwin C. Moody Jr., first chief of police, is standing to the right. Cedar Lake was the first Indiana town to have take-home police cars. Until 1994, used state police cars in good shape were bought, saving the town a lot of money. James Hunley was the second chief, followed by Charles Kouder, Barry W. Wornhoff, and currently Roger Patz. (RH.)

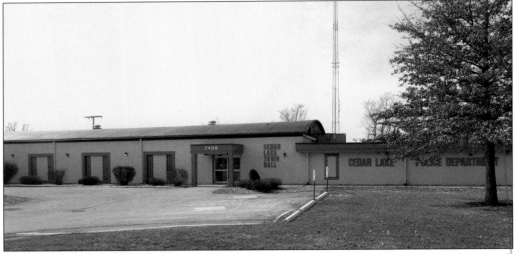

Christopher Lassen ran an auto repair out of this building in 1933, shown in this photograph taken on March 14, 2011. In 1937, Ambrose Rascher organized wrestling matches here with famous athletes like Battling Nelson. After the town purchased the property and made renovations, the town hall and police department were moved into the building at 7408 Constitution Avenue in the late 1970s, providing them with a much larger facility. In 1995, the 911 emergency service was added. (CO.)

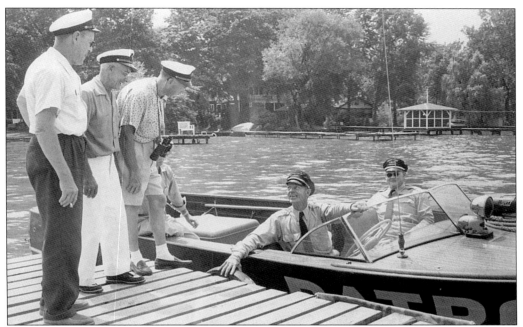

The all-volunteer Cedar Lake Patrol Service was formed in 1951 and continued through the 1970s. The service was privately funded until it became too expensive to maintain. The DNR currently patrols the lake periodically, and the police and fire departments respond to emergency calls. Pictured here are, from left to right, Art Larson, Bill Wilson, William P. Dudley, patrolmen Ed Shimko, and Bill Boren before a sailboat race. (LRCM.)

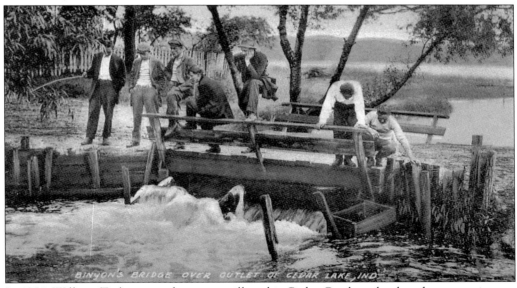

In 1854, William Taylor erected a steam mill at this Cedar Creek outlet, but the enterprise was not profitable. Cedar Creek flowed east out of Cedar Lake along a narrow valley, then 13 miles south to the Kankakee River. That valley became man-made Lake Dalecarlia in 1927. The outlet was dammed and is now maintained by the Indiana Department of Natural Resources. Young boys still gather here to fish. (ADS.)

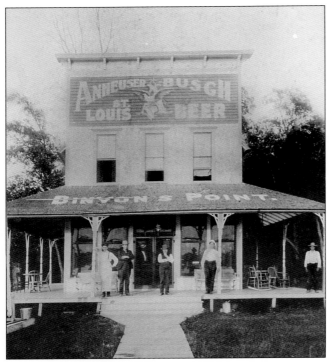

Eighteen-year-old John Binyon and his 15-year-old bride Nancy came on horseback from Tennessee in 1840. Around 1870, John and son Christopher (Crip) Binyon bought the previously Taylor-owned property, built a hotel at water's edge, and called it Binyon's Point, pictured here in this 1885 photograph. In the 1880s, the hotel was accessible by water or inland foot trails. The next owner was Harry Clark, then Luke Trotter. (LRCM.)

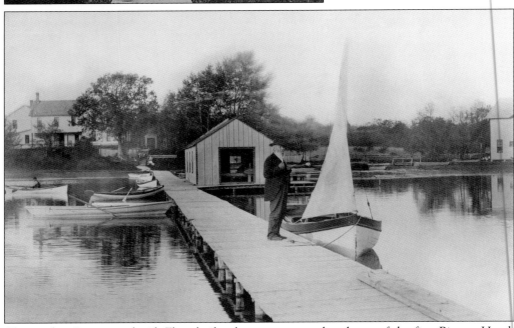

Christopher Binyon and wife Flora built a larger two-story hotel east of the first Binyon Hotel. The elegant hotel was well managed with a good reputation. On busy weekends in the 1920s, five hundred chicken dinners would be served for 50¢ each, and rowboats were available for rent. Fred Binyon is pictured on the Binyon pier with an Olson-built sailboat. Binyon descendents ran Binyon's Restaurant in Chicago for many years. (FH.)

Dr. William Misch served as a Battle of the Bulge medic before starting his Cedar Lake practice with Dr. Robert King. Then, Dr. Misch built a clinic at 13963 Morse Street. The closest hospital was Hammond, so surgery, baby deliveries, and urgent care were offered in the clinic where son Dr. Jon Misch continues to practice. Next door is Dr. Rich Kazwell, DDS, who also followed his father's profession. (CO.)

Ten cloverleaf-shaped houses were purchased from the 1893 Columbian Exposition in Chicago. The round buildings were incorporated into Charles and Nellie Straight's Shamrock Inn in Straight's Subdivision. Some of the buildings became part of currently existing homes. The Noble Hunting and Fishing Club stood west of the inn. Eugene and Geraldine Quinn purchased that area in the 1940s to become the still operating Quinn's Cottages, now owned by Ray Ferry. (LRCM.)

This Sans Souci Hotel was built by Charles Sigler on 260 feet of eastern lakeshore in 1896. Sans Souci is French for "without worries." The hotel was a musician's retreat. Jazz musician Paul Ash once climbed on the roof at 5:00 a.m. and serenaded the neighborhood with the "Wabash Blues." The French Boat Club was in this same area, and the hotel is currently an apartment house. (ADS.)

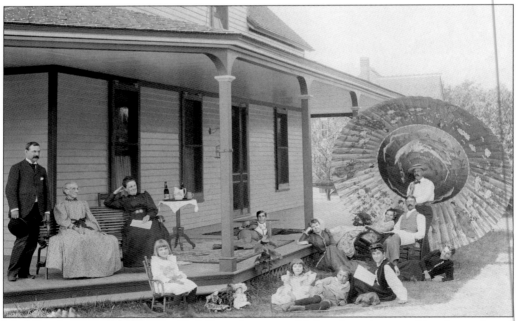

Mark Reed grew wealthy from his Red Cross shoe stores. He bought a pioneer cabin, then enlarged and remodeled it into this summer home. The Reeds enjoyed entertaining but had no children. One day, a lawyer came to niece Leta Francis Reed Kouder, grandmother of Chuck Kouder, to inform her she had inherited the Reed property called Idlewilde. It was later sold, and the area became private residences. (LRCM.)

Four

SOUTH SIDE

SURPRISE PARK GOLF COURSE, CEDAR LAKE, IND.

Pierre Suprenant, Americanized to Peter Surprise, took an Indian wife, LaRosa Taylor. Grandson William Surprise purchased 40 acres of hilly, swampy terrain for $2.50 an acre, and folks called him a fool. He farmed the land and built a log cabin near what is currently the second tee of the South Shore Country Club. In 1928, William's sons Glenn and Cass Surprise turned that family farmland into Surprise Park Golf Course. (SR.)

Charles "Chic" Evans designed the championship golf course prized for its ravines and irregularity. A clubhouse was built over the water next to a tall waterslide in 1928. The slide was said to be Cedar Lake's highest, and the amphibious airplane gave rides. The clubhouse and slide were removed in 1980. Cass Surprise maintained the law in Surprise Subdivision with two 45s in hip holsters. Surprise holdings totaled 145 acres. (ADS.)

This work crew posed inside the icehouse Cass Surprise built in 1934, at Morse Street and West 145th Avenue. Artificial ice was manufactured here, which claimed to be healthier than lake ice; however, refrigerators became popular and the business did not prosper. In 1974, the building was divided into apartments. Thickly insulated walls kept a 1990 fire from totally destroying the building, which continues as an apartment house. (AZ.)

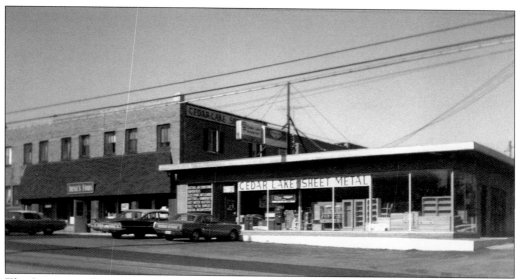

The Surprise icehouse had a north-south wing that has held Cedar Lake Sheet Metal, Peterman's Auto Sales, and Bill Landske Golf Carts. In 2006, Don King purchased the wing and established Lakeside Marina. Cass Surprise will be remembered for all the development he brought to Cedar Lake, yet he died in 1954 from what is believed to be a self-inflicted gunshot wound, after suffering from crippling arthritis. (LRCM.)

Cass Surprise had two sons, Roy and Julius. Roy "Lightning" Surprise operated Surprise Hardware on the northeast corner across from the icehouse, present-day Carrie's Resale. Julius Surprise ran Tastee Freeze on the southwest corner for 42 years. Heidi Mees-Duncan remembers Julius as a prankster who put pickles in her ice cream. Vacant since 1998, Debra and David Carey renovated the local landmark and opened it on April 30, 2010, as Tastee Top. (BC.)

The Surprise Golf Course and clubhouse closed during World War II. The property was sold to successive owners Charles McKay, Joseph Paul, Cliff Logan, and then to Cecil and Mary Hays in the early 1980s, with Charles, Marion, and Robert LoVerde as shareholders. The current clubhouse overlooking the lake was built in 1980, with Johnny Hays as the current manager. This photograph is dated 2006. (CO.)

Elizabeth Hill Surprise inherited 35.92 acres south of the country club. She sold the property in 1922 for $6,000. Lots were laid out for the South Shore Subdivision. Property owners have lake rights and pay annual dues for beach maintenance. The original pier was replaced in 1977, and the replacement is one of the longest and sturdiest piers on the lake. Here, from left to right, brothers Joe and Jack Oostman relax on the South Shore pier in 1983. (CO.)

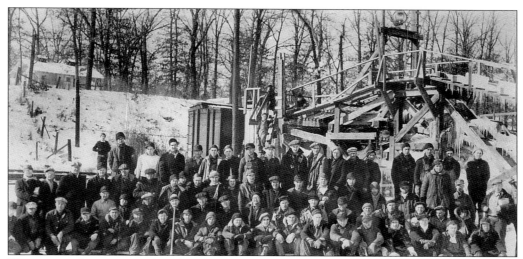

These ice workers were employed on the southern shore by either the Knickerbocker or Consumer Ice Company. Anderson and Freeman Ice Company was another enterprise located on the south end. William Surprise was involved in a southern shore ice war. The court case established riparian rights, which gave property owners the right to cut ice between their property lines and out to the middle of the lake. (LRCM.)

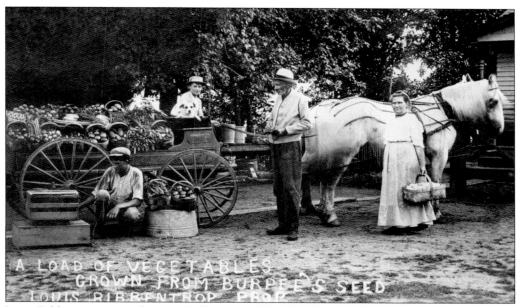

Louis Ribbentrop married Anna Hoffman, and they lived west of the William Surprise farm in early 1900s. Their marsh farmland produced bountiful crops. The Ribbentrop family made their living on daily rounds around the lake selling homegrown produce to local residents. The Plank Road was adjacent to Ribbentrop land, and Louis likely guided his team on the mile-long, narrow, swamp roadway to sell his goods in Creston. (LRCM.)

In 1916, Cordie Coffin and his mother, Emma D. Coffin, bought Obadiah Taylor III's land south of the lake. A Monon Railroad spur turned off from the main track and ran east along the southern shore. This is Coffin's property around 1926, with the tracks right on the shore. The tracks ran to the Anderson Freeman ice barn and were used as a holding area for cars waiting to be loaded. (RH.)

Cordie Coffin left Cedar Lake to serve in World War I. He returned in 1919 to develop the southern shore as Coffin's Shady Beach. The first people stayed in tents before cottages and cabins were built. Pictured in front of the snack shop is Emma D. Coffin in the rocker and Cordie in the doorway. The two small children are Cordie's sons Marian and Merritt Coffin. (LRCM.)

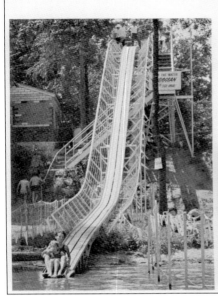

Merritt Coffin took over the resort in 1950. His son Larry Coffin and wife Sue managed the resort for around six years, then Merritt's son Terry Coffin took over and bought it in 1990. Merritt built the steel-walled, two-story slide. In the summer, a two-person cart with wheels went down the slide, and a six-foot toboggan was used in the winter. The railroad tracks were removed, and the beach was widened. The public resort became private in the 1960s. Vacationers sent home postcards like these showing the slide and the beach. Cordie Coffin's original property included part of Pine Crest Marina and extended almost to Cline Avenue. Parcels were sold off over the years, and Terry sold the remaining five-acre resort property around 2000. In 2006, development began with private residences and it is now called South Beach. (Above, MK; right, RH.)

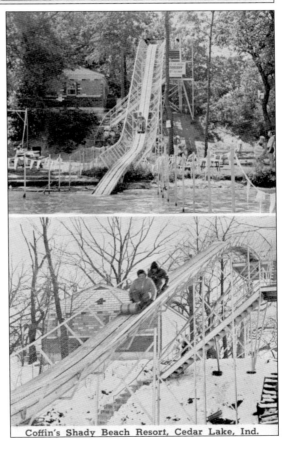

Coffin's Shady Beach Resort, Cedar Lake, Ind.

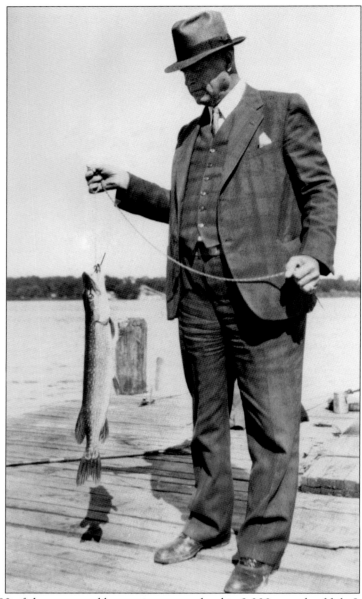

In the late 1880s, fishermen used large seine nets to haul in 2,000 pounds of fish. Jean Shepherd's story "Hairy Gertz and the Forty-Seven Crappies" first appeared in the June 1964 issue of *Playboy*. In Shepherd's sarcastic style, he recounts the horrors and joys of his first fishing trip in Cedar Lake, Indiana. In 1966, Indiana stunned the fish to eliminate the scavengers, but the scavengers were not totally eliminated and kept eating the bass and bluegill eggs. Crappie, bass, catfish, bluegill, yellow perch, and northern pike were good fish. Carp and white perch were garbage fish. In 1978, the Indiana Department of Natural Resources stocked the lake with 4,000 catfish. Pickerel Creek ran through the east end of Coffin's Shady Beach and now South Beach. Pickerel migrated from the lake through the creek to the marsh to spawn and then returned to the lake. This pickerel was caught from Coffin's pier. The fish population has dwindled, but hopefully next year (it is always next year!), after the lake is dredged, the days of plentiful fish will return. (RH.)

Five

PRESENT DAY

Potawatomi Park, located on the old Potawatomi Indian trail, was dedicated in 1974 to the memory of those first individuals who lived here. This is one of 20 Cedar Lake parks, totaling 163 acres. The Lions Club built the nearby lookout with benches and flagpoles, and it was dedicated in 1985. The town currently maintains the park and lookout. (CO.)

This 2006 photograph shows the fascination with water and speeding over the waves never ends, whether under sail or with a motor. Pine Crest Marina and North Point Marina service boaters, and the chamber of commerce has a public launch. Food is available lakeside from the View, Boondocks, the Lighthouse, and Dairy Queen. We have come a long way from Indian dugout canoes to jet skis, pontoons, sailboats, and speedboats. (CO.)

The Cedar Lake Chamber of Commerce has sponsored the annual June fishing derby since 2004. Children ages one to 12 are welcome to participate at the chamber's lakeside property on the north end. Corky's Dog House provides lunch, and prizes are awarded in several categories. From left to right, brothers Jake and Travis Oostman try to catch the big one in 2010. (CO.)

Florence Wahlberg, Eileen Hunley, Sue Summers, Karen Dowler, and Mary Joan Dickson started Summerfest. The Independence Day celebration is run by volunteers and funded through donations. A softball tournament between public service employees was held the first year. Over the years, there have been helicopter rides, mud wrestling, boat rides, car shows, and pancake breakfasts. Each year is different, but there are always food vendors and a grand finale of fireworks. The 30th birthday celebration of Summerfest was held from July 1 to July 4, 2011. Pictured from top to bottom is a 2010 cardboard boat race entry, 2006 checkers tournament participants on the museum porch, and undated fireworks over the lake. (BC, CP.)

Winter is not a time to hibernate. When the ice is safe, it is time to bundle up and clear the snow for an ice rink. Skating areas are seen all around the lake, and the frozen expanse is also crisscrossed with snowmobile tracks. Iceboats are seen racing with the wind in their sails. This photograph was taken at the south end on December 16, 2010. (CO.)

Ice racing on Cedar Lake was big in the 1970s and 1980s, and later, the interest in the sport dwindled. In January 2009, Moto on Ice brought back the action. This photograph, taken on January 9, 2011, shows several classes of motorcycles, three-wheelers, and four-wheelers competing on the lake in front of the South Shore Country Club. The races run during January and February, depending on ice quality. (CO.)

Six

MAPS

This lake was glacier formed, and the Continental Divide crosses town. The township line runs north and south across the lake, creating east-siders, west-siders, and sometimes lake rats. The wealthy, the poor, the good, and the bad have lived here, and each made contributions to the area's history. The same mixture exists today and continues to add to the Cedar Lake story. (CO.)

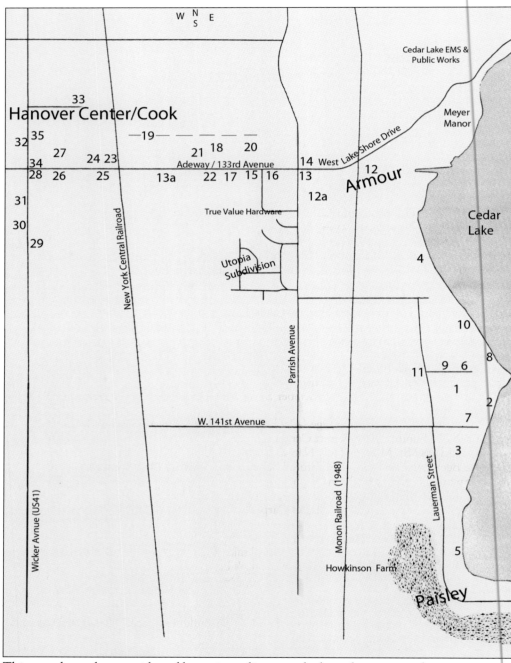

Hanover Center/Cook

33

32 35
34
28 26
31
30
29

27 24 23

25

—19—

21 18 20

Adeway / 133rd Avenue

13a

22 17 15 16

True Value Hardware

Utopia
Subdivision

14 West Lake Shore Drive

13
12a

12
Armour

Cedar Lake EMS &
Public Works

Meyer
Manor

Cedar
Lake

4

10
8
9 6
11
1
2
7
3

5

New York Central Railroad

Parrish Avenue

W. 141st Avenue

Wicker Avnue (US41)

Monon Railroad (1948)

Howkinson Farm

Lauerman Street

Paisley

This map shows the west side and key points of interest; the legend appears on the opposite page. This and the following three maps are not to scale or based on a particular time period. They are intended to give a general idea of place location in relation to today.

122

WEST SIDE

1. West Side Shopping Center, also called Biesecker Row
2. Monon Depot 1898
3. First Monon Park / Noble Oaks Park / Noble Oaks Subdivision
4. Second Monon Park / Moody Conference Grounds
5. Paisley Depot / Pinecrest Resort
6. Lighthouse Baptist Church
7. Big 3 Inn
8. Monon Hotel also known as the Sigler Hotel
9. Chappell's Super Service
10. Glendenning Hotel
11. Gerbing Saloon and the Einsele Hotel, later the Hanover House
12. First Jane Ball School
12a. Current Jane Ball Elementary School
13. Airline Drive Inn / First Cedar Lake Kitchen
13a. Cedar Lake Kitchen 2011
14. Lincoln School of 1912 to 1991 / Hanover Community School Corporation offices
15. Mager Appliance Store / Faith Church Community Arts Center
16. Dr. Robert King's Medical Office
17. Current Cedar Lake Post Office
18. Current Lake County Public Library–Cedar Lake Branch
19. Cedar Lake Airport / Hanover Central Junior and Senior High School
20. Cedar Lake Animal Hospital
21. Go-cart track
22. Cedar Lake Golfatorium / Burger King
23. Nichols Grain and Hay Company
24. The Lauerman Store / J&P Schrieber Store / IGA Grocery Store / Gateway Christian Fellowship
25. The Hein Hotel / Cook's Lounge / Cook Gardens / Homescapes Garden Center
26. Shillo Blacksmith / John Schutz Center Garage
27. St. Matthias / St. Martin / Holy Name Catholic Church
28. The Beckman Store / Massoth Store / Schafer Gas Station / Mees Insurance
29. Henn and Sons Construction
30. Community Bible Church
31. Leo and Sons and Yancey's House of Carpet
32. Gard Laundromat
33. Great Oaks Banquets
34. Lorenz and Elizabeth Bixenman's home and saloon
34a. Joseph and Bertha Bixenman's Tavern / Carlo's Pizza

The slash between names indicates a timeline for that building or area. The first name is the oldest, followed by the next occupant, and so on.

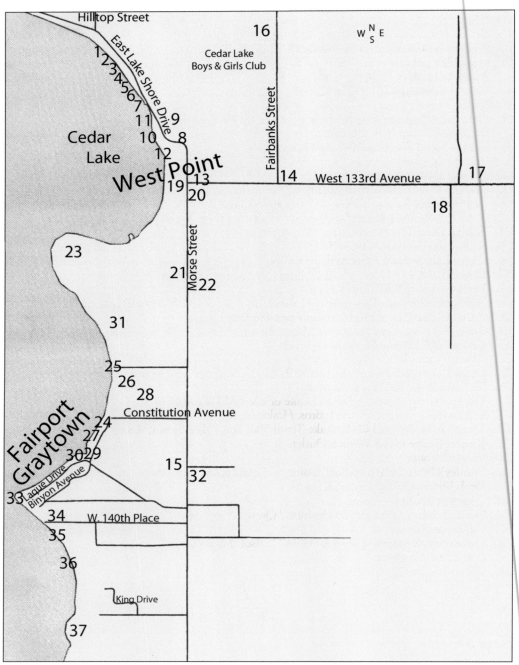

This map shows the east side and key points of interest; the legend appears on the opposite page.

EAST SIDE

1. Samuel Bartlett's second sales office
2. Lake Shore Hardware / RBB Realty
3. Young's Place
4. Zeigers Bakery / Kohler's Bakery
5. Bartlett Park
6. Wahlberg Photography / Wahlberg Panoramic Photography
7. Edgewater Beach / Town Club
8. Stife's Place / East Side Shopping Center
9. Top Flight Hotel / Pier 74 Pizza and Grill
10. Present Dairy Queen
11. Midway Gardens / Midway Ballroom
12. Derby Hotel / Kennedy Hotel / Cedar Lake Roller Rink (all are in the general area)
13. Ray's Roadhouse / Russell's / Coleman's Corner / Lake Shore True Value Hardware
14. TJT General Tire Service, Inc.
15. Red Cedar School / Binyon School
16. Cedar Lake School / MacArthur School
17. Lemon Lake
18. Robin's Nest Subdivision
19. Burke Hotel / Gaslight Lounge / Holiday Liquors / Sunset Harbor Condominiums
20. Rose's Corner / Peterman Car Lot / new Holiday Liquors
21. Royal Blue Grocery / Lakefront Maintenance
22. Cedar Lake United Methodist Church
23. Thistlewaite Hotel / Cedar Point
24. Lassen Ice House / Tea Pot Dome / Tobe's Restaurant / Lighthouse Restaurant
25. The Lassen home / Yacht Club
26. Lassen Hotel / Hotel Christian / Lake of the Red Cedars Museum
27. Lassen Boat Repair / Gornick Bros. / Lakeside Marina
28. Lassen Auto Repair / Cedar Lake Town Hall and Police Department
29. Binyon Bridge / Cedar Creek Outlet
30. Binyon's Point
31. Stanley's Place / Hickory Subdivision/Henderlong Subdivision
32. Dr. J. Misch, DO, and Dr. R Kazwell, DDS
33. Toomey's Resort
34. Shamrock Inn / Straight Subdivision / Quinn's Cottages
35. San Souci Hotel
36. Olson Hotels / Norwegian Boat Club / Wilson Subdivision
37. The Idlewilde estate

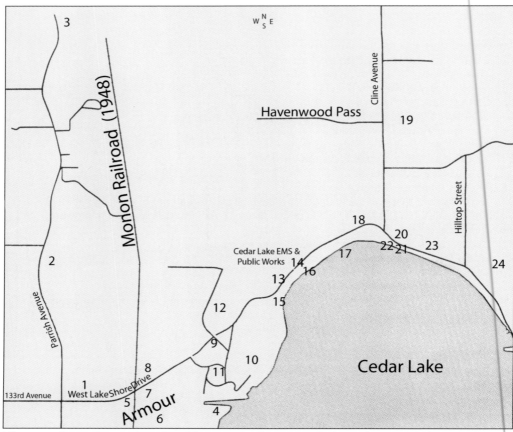

This map shows the north end and key points of interest; the legend appears below.

North End

1. Cedar Lake Fire Department
2. Einsele Hotel / Lourdes Retreat
3. Lincolnshire Estate
4. Armour and Shedd Ice Barns
5. Armour Town memorial rock
6. Cedar Lake Handle Factory
7. GeScheidler Bell Factory / Cedar Lake Lumber
8. Massoth and Armour Depot Store / Genzler Dance Hall /Cedar Lake Transit/ Smith Ready Mix
9. Poltz Grocery / Hunley's Restaurant and Bar
10. Meyer Manor
11. Indian burial mound
12. Meyer Terrace
13. Cedar Lake Florist
14. The Meyer home / Lions Club clubhouse / Eller-Brady Funeral Home
15. Potawatomie Park
16. Lookout
17. Lakeview Hotel / Water's Edge Condominiums
18. Blizzard's Grocery
19. Salesian School
20. Bartlett Office / Aanerud and Zimmerman property
21. Dick Smith's / Bartell's Resort / Chamber of Commerce
22. Victor's Beach
23. Cedar Theatre
24. Huntsman's Lodge

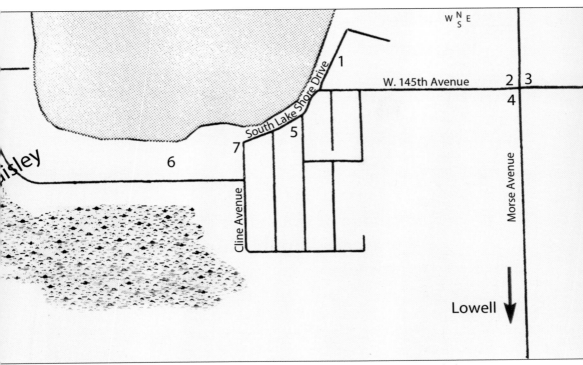

This map shows the south end and key points of interest; the legend appears below.

SOUTH END

1. Surprise Park Golf Course / South Shore Country Club
2. Surprise ice house / Lakeside Marina
3. Surprise Hardware / Carrie's Resale Shop
4. Tastee Freeze / Tastee Top
5. South Shore Subdivision
6. Coffin's Shady Beach / South Beach
7. Anderson and Freeman Ice Company

Discover Thousands of Local History Books
Featuring Millions of Vintage Images

Arcadia Publishing, the leading local history publisher in the United States, is committed to making history accessible and meaningful through publishing books that celebrate and preserve the heritage of America's people and places.

Find more books like this at
www.arcadiapublishing.com

Search for your hometown history, your old stomping grounds, and even your favorite sports team.